# ATASCOSA COUNTY
### IMAGES of America

ON THE COVER: Pictured is O.G. Barrow General Store in Poteet, Texas. Later, it became Crouch's Store, operated by Barrow's nephew. Today, the building location is the Poteet City Hall. (Courtesy of Bryan Crouch.)

# IMAGES of America
# ATASCOSA COUNTY

Martin Gonzales and the
Atascosa County Historical Commission

Copyright © 2024 by Martin Gonzales and the Atascosa County Historical Commission
ISBN 978-1-4671-0883-6

Published by Arcadia Publishing
Charleston, South Carolina

Printed in the United States of America

Library of Congress Control Number: 2023947579

For all general information, please contact Arcadia Publishing:
Telephone 843-853-2070
Fax 843-853-0044
E-mail sales@arcadiapublishing.com

Visit us on the Internet at www.arcadiapublishing.com

*To the citizens of Atascosa County past, present,
and future. Treasure our rich history.*

# Contents

Acknowledgments 6

Introduction 7

1. Pleasanton Area 9
2. Poteet 41
3. Jourdanton 83
4. McCoy and Campbellton 111

# ACKNOWLEDGMENTS

The photographs used in this publication were from many sources and are property of private citizens. The citizens of Atascosa County were called to volunteer historic photographs, and they did not disappoint. The Atascosa County Historical Commission's help in sorting and choosing photographs was a difficult task.

# Introduction

Since its creation in 1856, Atascosa County has been an increasing population area with the rural feel of the country. Just south of San Antonio, Atascosa County has been a place for the capture of the imagination with the local legends, the myths and most unbelievable, and the real cast of characters who have resided in Atascosa County.

Prior to 1856, this land of Atascosa was a ranch for the San Antonio missions where Atascosa County's first cowboys were born. Later, it was used as a retreat and passing point for revolutions and those involved. As the settlers trickled in, they were met with challenges. Challenges from the native land and the indigenous people that at times could become violent. Nonetheless, the early settlers and pioneers persevered, and their descendants continue to thrive today.

Col. Jose Antonio Navarro, signer to the Texas Declaration of Independence and Atascosa native, donated a portion of his land for a courthouse in 1857. Colonel Navarro and his family were critical to the development and settlement of Atascosa County.

As the late Judge Robert Thonhoff described it, "Atascosa County has had all the elements for an exciting history: Indians, explorers, conquistadores, padres, soldiers, cowboys, armies on the move, trail drives, railroads, land schemes, county seat changes, droughts, depression, boom times and much more." Judge Thonhoff was a longtime educator and historian in Atascosa County. His research was impeccable, and thus, I have chosen to use his words as they serve for a most perfect description.

Today, Atascosa County is made up of multiple cities and several unincorporated communities. Jourdanton, the county seat since 1910, is the center of Atascosa County business. Pleasanton is the highest populated city in the county, followed by Poteet (the Strawberry Capital of Texas), Lytle, and Charlotte. Leming, Christine, Campbellton, and Rossville serve the county as towns and unincorporated communities. The ranching and farming industry are prominent in Atascosa County.

In conclusion, what you will see is a view through time of Atascosa County. We have attempted to use photographs never seen before. The different communities throughout our beautiful land have been captured and will be shared for generations to come. Enjoy your voyage through time, and please share this with the forthcoming young people of Atascosa County.

# One
# PLEASANTON AREA

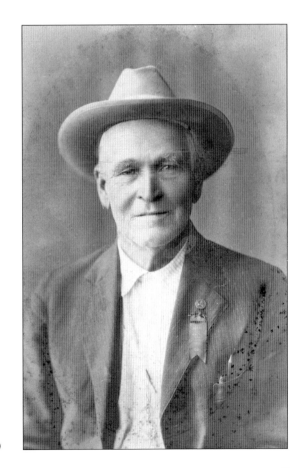

Atascosa County was established by the Texas Legislature in June 1856. William Thomas (known as W.T.) Brite was the first person to be born in the newly organized Atascosa County on July 24, 1856. According to the federal census in 1860, Atascosa County recorded a population of 1,578. Brite was an active member of his community and a well-known figure of all things Atascosa County. (Courtesy of Norman Porter Jr.)

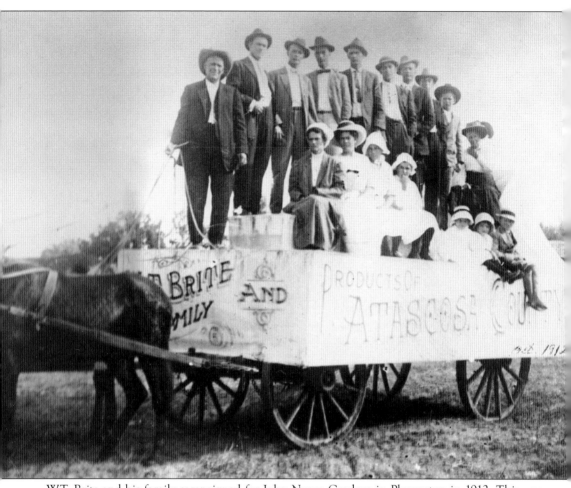

W.T. Brite and his family campaigned for John Nance Gardner in Pleasanton in 1912. This was during a reelection bid for the Texas House of Representatives. Garner would go on to eventually become the vice president of the United States under Franklin Roosevelt. (Courtesy of Norman Porter Jr.)

February 25, 1929, was the 50th wedding anniversary of W.T. and Mary Brite in Verdi, Texas. Brite married Mary Hester on February 25, 1879, in Atascosa County. Their celebration was regarded as a large affair in the rural Atascosa County. (Courtesy of Norman Porter Jr.)

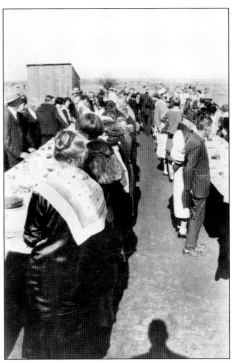

W.T. Brite is pictured along with his wife, Mary, and their 15 children in Pleasanton, Texas. (Courtesy of Norman Porter Jr.)

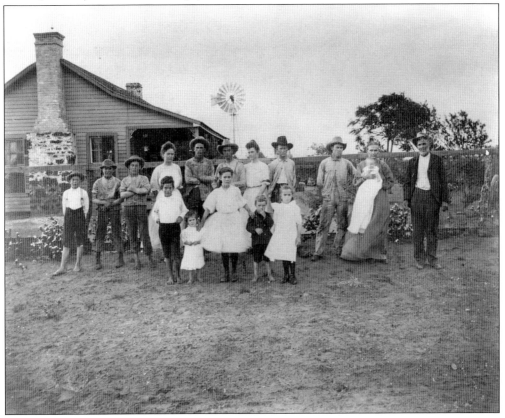

John Patton McCarley was born in 1824 shortly after his parents, Samuel and Celia (Franks) McCarley arrived in Texas with Stephen F. Austin's Second Colony. In 1843 in Montgomery County, Texas, he married Amanda Burleson, the daughter of Aaron and Rebecca Burleson. The family left Caldwell County in the early 1850s and settled near Pleasanton. Amanda died January 1, 1857, and in 1858 McCarley married Edna Musgraves, the daughter of Calvin and Mary Musgraves. Edna died around 1860. McCarley was a Texas Ranger and served under Capt. Levi English, his brother-in-law, with the Texas Mounted Volunteers, which was made up of men from the Pleasanton area for protection against the Indians. He was also a veteran of the Mexican-American War in the Texas Ranger Service under Capt. Henry McCulloch. McCarley died in 1885 and is buried in Carrizo Springs, Dimmit County, Texas. (Courtesy of Camilla Allen Mitchell.)

Jeremiah Stuart Pearce was born in 1839 in Arkansas to Samuel Ellis and Cynthia (Hooper) Pearce. In the early 1850s, they moved with other Sevier County, Arkansas, family members and neighbors and settled in the Verdi area that became Atascosa County. Samuel was the first pastor of Old Rock Baptist Church and an early pastor of Shiloh Baptist, the two oldest Baptist churches in the county. In 1867, Jeremiah married Charity Melvina McMains, his childhood neighbor. They had eight children born in the Verdi area. (Courtesy of Camilla Allen Mitchell.)

Pictured here are Charity (McMains) Pearce (left) and Rosa Moffit (right). Charity, the oldest daughter of Andrew and Mary Caroline (Hayes) McMains, was born in Missouri in 1846. She and her husband, Jeremiah Pearce, lived most of the their lives in the area of Verdi and Fairview. They also owned property in Pleasanton. Following their son George and various family members, they moved to Dimmit County, where Jeremiah died in 1900 and Charity died in 1905. They are buried in Carrizo Springs. (Courtesy of Camilla Allen Mitchell.)

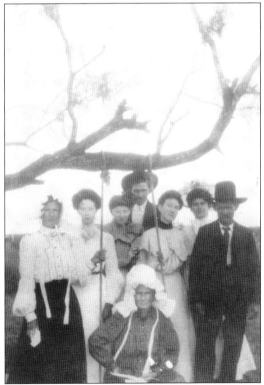

Charity (McMains) Pearce (front center) is seen with some of her children and family members. Charity was born in Missouri in 1846, and at the age of four, her parents, Andrew and Mary McMains, moved to Arkansas. In the 1850s, the McMains family resided in Atascosa County. (Courtesy of Camilla Allen Mitchell.)

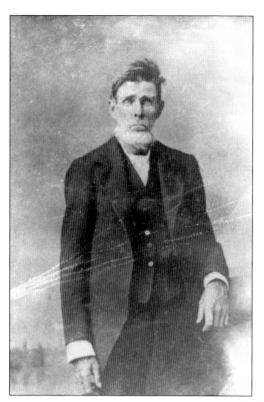

Andrew McMains was born in 1817 in Kentucky, the son of Abraham and Margaret (Mitchell) McMains. He and Mary Caroline Hayes, the daughter of Joseph and Lavina (Young) Hayes, were married in Missouri. Lavina died in Missouri, and the Hayes and McMains families moved to Arkansas and then to the Verdi area in the early 1850s. They had 11 children, and many of their descendants still live in the area. Andrew was a leader of the Verdi Church of Christ. Mary Caroline died in 1864, and Andrew died in 1894. He is buried in the Fairview Cemetery, and she is believed to be buried beside him in an unmarked grave. (Courtesy of Camilla Allen Mitchell.)

George Washington Pearce was born in 1876 in Verdi, Texas, the son of Jeremiah and Charity (McMains) Pearce. George grew up working on his family's ranch and moved as a young man to Dimmit County to work on the ranches of his McMains uncles. In 1901 in Dimmit County, he married Donie Ella Bell, the daughter of William Van and Matilda Jane (McCarley) Bell. She was born in 1881 in Seven Rivers, New Mexico, where her father had gone to work as a freighter. George died in 1949, Donie in 1953, and they are buried in Carrizo Springs. (Courtesy of Camilla Allen Mitchell.)

Pictured are, left to right, Marion Thomas Allen Sr., Camilla Allen, and Bertha Maye (Pearce) Allen in Charlotte, Texas, in 1949. The Allen family consisted of four siblings and their parents, Marion Allen Sr. and Bertha Maye Allen. (Courtesy of Camilla Allen Mitchell.)

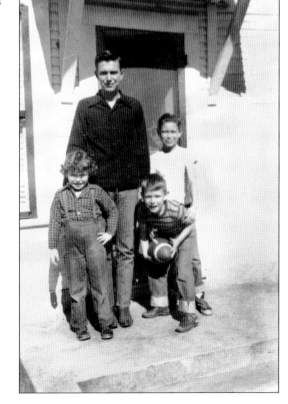

Pictured are, from left to right, siblings Camilla Allen, Marion Allen Jr., Doug Allen, and George Allen. The picture was taken in Pleasanton in 1953. Their parents were Marion Thomas Sr. and Bertha Maye (Pearce) Allen. (Courtesy of Camilla Allen Mitchell.)

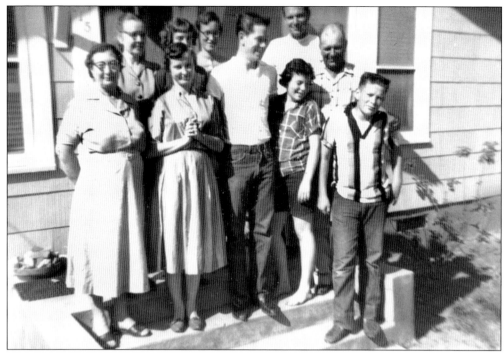

Pictured in April 1959 in Pleasanton, Texas, are, from left to right, Alline Burson, Lottie (Pearce) Hines, June (Burson) Allen, Betty Sue Hines, Jo (Burson) Cade, George Allen, Marion Allen Jr., Camilla Allen, Marion Allen Sr., and Doug Allen. (Courtesy of Camilla Allen Mitchell.)

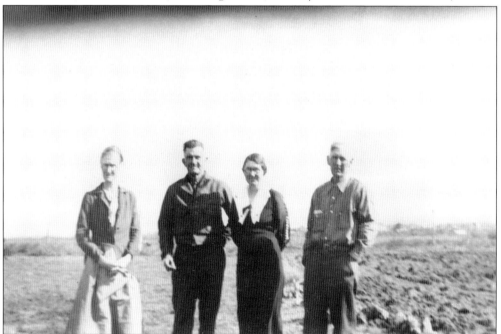

Pictured left to right are Cynthia (Pearce) Hargus, Robert Pearce, Agnes (Pearce) Hinton, and George Pearce, who were all born in Verdi, Texas. They are the children of Charity (McMains) Pearce and Jeremiah Pearce. (Courtesy of Camilla Allen Mitchell.)

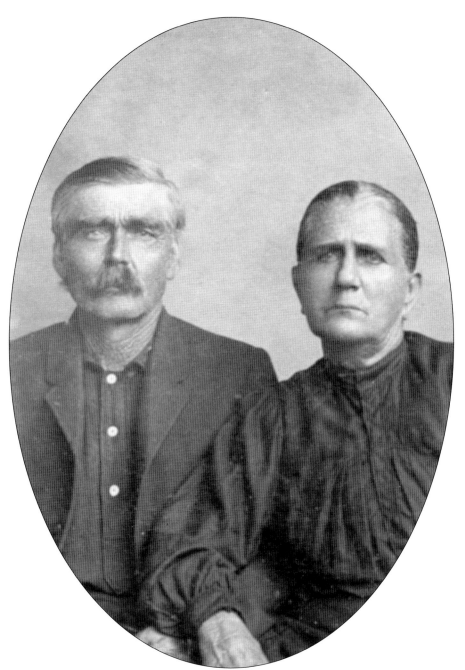

William Van "Bill" Bell was born in 1837 in Mississippi. His father, Jonathan Ruben Bell, was a freighter there and later in Texas. After Jonathan was killed, Bill, as the oldest of nine children, had the responsibility of finding homes for the younger children with friends in Karnes and Atascosa Counties. Born in 1847 in Caldwell County, Matilda Jane was the daughter of John Patton and Amanda (Burleson) McCarley. She had grown up in the Pleasanton area on property that her father sold to Thomas R. Brite. Bill and Matilda Jane were married in 1868 in Uvalde. She died in 1912 in Lockhart, Texas, and he died in 1920 in the Confederate Home in Austin. (Courtesy of Camilla Allen Mitchell.)

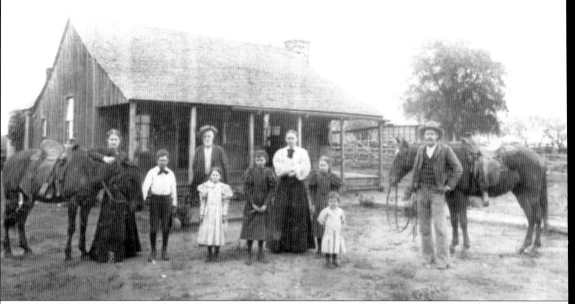

Pictured are, from left to right, Cynthia Pearce, Ben Fuller, Lottie Fuller, John S. Fuller, Mollie Fuller, Rebecca (McMains) Fuller, Asa Lou, Gay Fuller, and William Barton Fuller in front of Bart and Rebecca Fuller's home in Verdi, Texas. (Courtesy of Camilla Allen Mitchell.)

Fred Lyons (1866–1941) is shown at right, and Sallie (Cook) Lyons (1868–1959), below, is pictured with her infant son Ernest Lyons, who did not live past infancy. Sallie was the daughter of James Russell Cook Jr. and Mary Virginia McDonald. Both the Cook and Lyons families were early settlers of Pleasanton. Their house still stands today and is the first home to be on the national register in Atascosa County. It has been preserved, restored, and protected by the State of Texas and is known as the Frederick and Sallie Lyons House. The Lyons House, constructed between 1912 and 1913, represents one of the few surviving examples of the modified L-plan building-type home. (Both, courtesy of Camilla Allen Mitchell.)

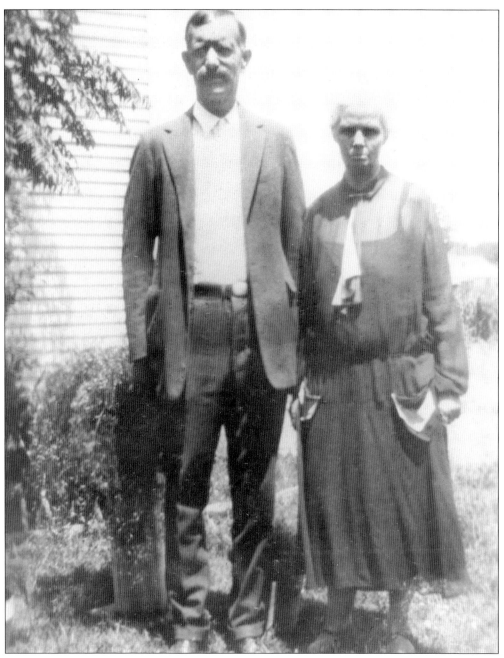

Fred and Sallie Lyons are pictured standing near their home. The Lyons family had early roots in Atascosa County's beginning. During this period of rapid growth, many of the rural residents of the county moved to Pleasanton to take advantage of the new economic prosperity. One of these was Frederick Thair Lyons, the son of pioneer Atascosa County settlers Edwin Ray Lyons and Mary Ann Blackmore. The Lyons family moved to Atascosa County in 1856, the year the county was formed. (Courtesy of Camilla Allen Mitchell.)

Thurman Jennings Mitchell (right) was born November 28, 1906, to William Andrew Mitchell and Fannie Jennings in La Casa, Stephens County, Texas. He graduated from Winters High School in 1927. Thurman met Bonnie Lee Lyons (below) when he was working for the construction company that was building US Highway 281, and they married on February 16, 1929. For a number of years, he was connected with Burmeister Motor Company of Pleasanton as head mechanic. Thurman and Bonnie Lee had four children, Joan, Freddie Lee, Thurman J., and Bonnie Beth. They were members of First Baptist Church in Pleasanton. On April 19, 1940, he died of a heart attack at age 33 while drinking coffee with friends at Mills Café. Bonnie Lee (Lyons) Mitchell, the daughter of Fred and Sallie Lyons, is pictured in typical dress of the 1920s. (Both, courtesy of Camilla Allen Mitchell.)

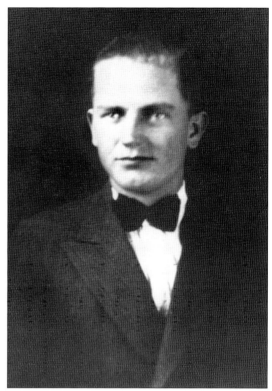

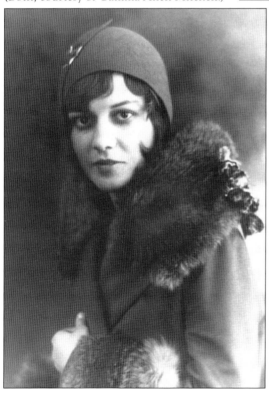

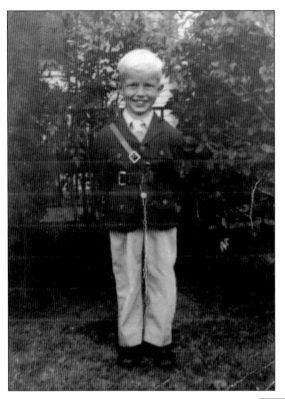

Thurman J. Mitchell, pictured in Pleasanton during World War II, is dressed in patriotic garb. He is the son of Thurman Mitchell and Bonnie Lee (Lyons) Mitchell. It was typical to see children dressed as such during the breakout of the world war to show support as a nation. (Courtesy of Camilla Allen Mitchell.)

The children of Thurman and Bonnie Mitchell are pictured here. From left to right are Bonnie Beth, Freddie Lee, Joan, and Thurman J. Mitchell at their home in Pleasanton, Texas. (Courtesy of Camilla Allen Mitchell.)

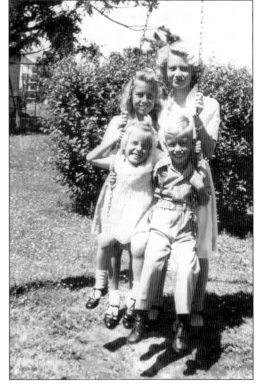

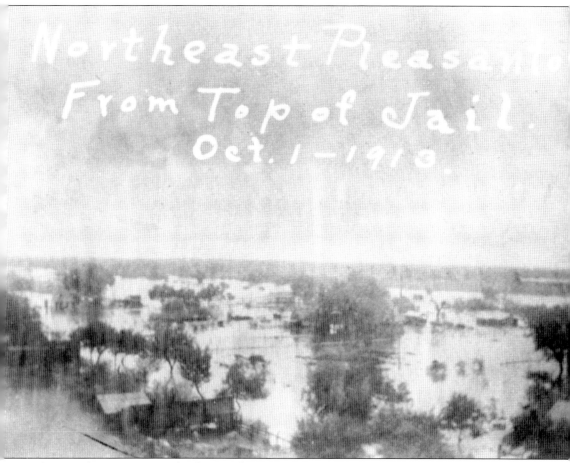

Above is the scene after a flood covered Atascosa County in 1913. This photograph was taken from the top of the county jail in Pleasanton, facing northeast. The old jail was located where the Pleasanton City Hall resides today. This shot would have faced the Atascosa River about a half mile away. (Courtesy of the Atascosa County Historical Commission.)

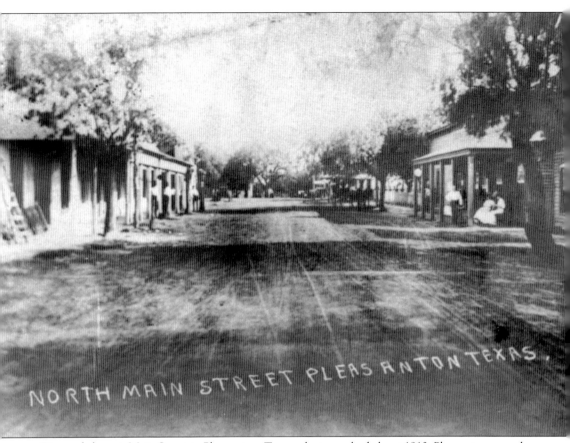

Pictured above is Main Street in Pleasanton, Texas, photographed about 1910. Pleasanton served as the Atascosa County seat from 1858 to 1910. Known as the "Birthplace of the Cowboy," a festival is held annually to celebrate the cowboy heritage and lifestyle. Pleasanton served as a stopover for the Great Western Cattle Trail in the late 1800s through the Matamoros Feeder Trail. (Courtesy of the Atascosa County Historical Commission.)

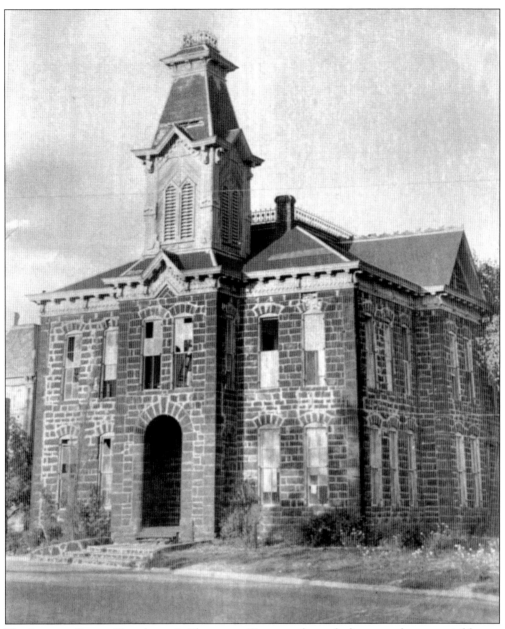

The Atascosa County Courthouse in Pleasanton, Texas, was located adjacent to the county jail (upper left), just northeast of that building. In this photograph, the jail is seen at left. This building began to crumble once the main road was constructed close to the structure. This road would eventually be US Highway 281. In 1956, the courthouse was demolished. Today, the City of Pleasanton uses this land because a new city hall was built there. (Courtesy of the Longhorn Museum.)

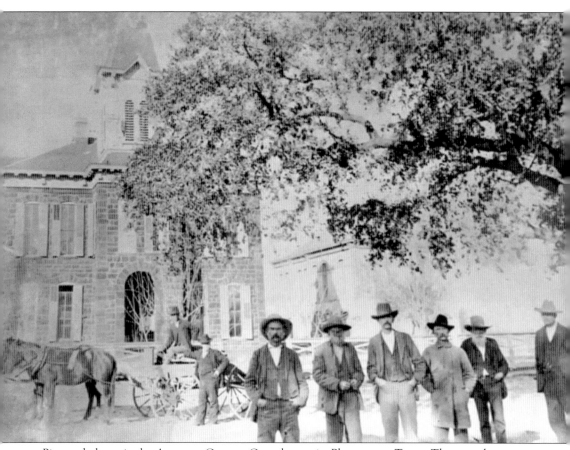

Pictured above is the Atascosa County Courthouse in Pleasanton, Texas. The courthouse was constructed in 1885 from red stone. It served as the county's official place business until a countywide election moved the county seat to its current location in Jourdanton. (Courtesy of the Longhorn Museum.)

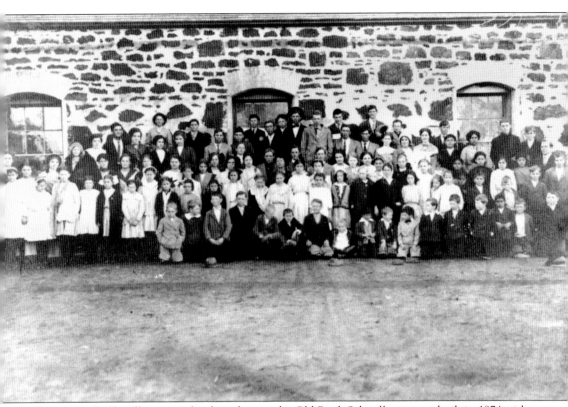

Constructed of locally quarried red sandstone, the Old Rock Schoolhouse was built in 1874 with funds pledged by citizens of Pleasanton. Once completed, the building was deeded to the county for free public school purposes. In addition to its educational function, the schoolhouse also served as a place of worship for First Baptist Church from 1875 to 1883. A storm cellar in the schoolyard served as a sanctuary against Comanche Indian raids on many occasions. (Courtesy of the Atascosa County Historical Commission.)

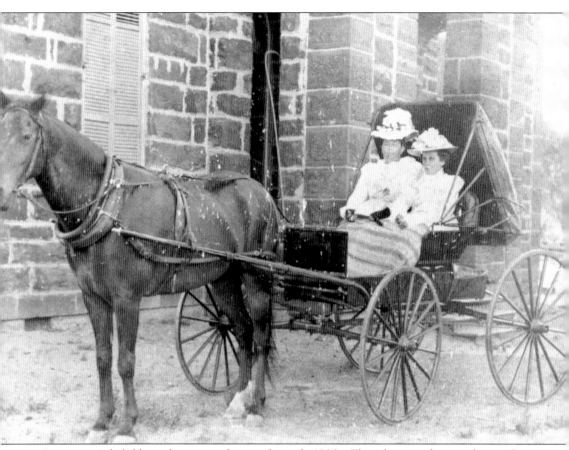

A woman and child are shown traveling in the early 1900s. This photograph was taken in front of the courthouse when it was located in Pleasanton. Pleasanton held the county seat from 1858 to 1910 until a local election moved the county seat to its current location in Jourdanton. The courthouse was standing until the 1950s when the building began to deteriorate. It was eventually demolished. (Courtesy of the Atascosa County Historical Commission.)

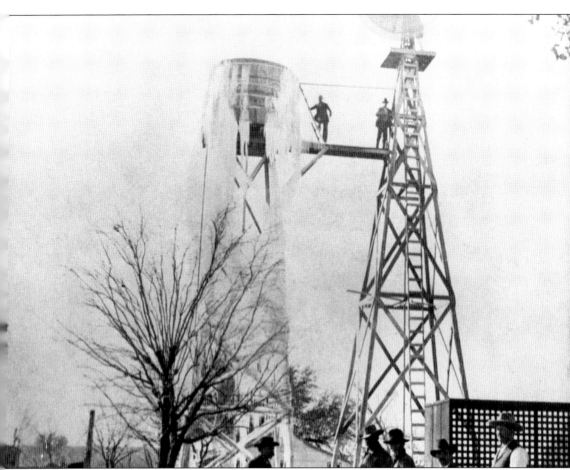

Atascosa County's placement in South Texas makes for hot summers and mild winters. However, a brutal winter will come about every few years to grab some attention. Here, a windmill stands frozen outside of the county courthouse in Pleasanton. (Courtesy of Norman Porter Jr.)

The Rodriguez family have a historic Texas ancestry. This family lived a simple, rural, farm life. The family was proud to show off their homemade dresses, made by their mother, Ramona (Tijerina) Rodriguez. Standing here are Eloise Rodriguez (left) and Mary Felix Rodriguez (right) in June 1956. The girls' mother made their dresses from flour sacks and feed sacks. Even their brothers' school shirts were made by their mother. (Both, courtesy of Eloise Rodriguez.)

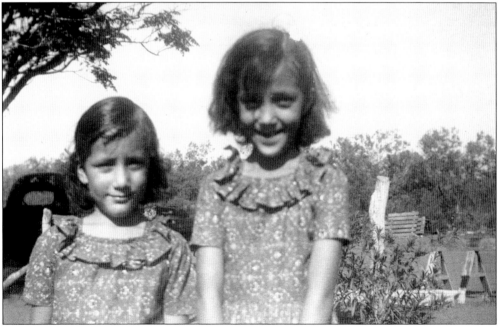

The patriarch of the Rodriguez family, Felix Rodriguez, is shown on his farm feeding chickens in December 1950. This scene is typical for rural, farm life in Atascosa County. (Courtesy of Eloise Rodriguez.)

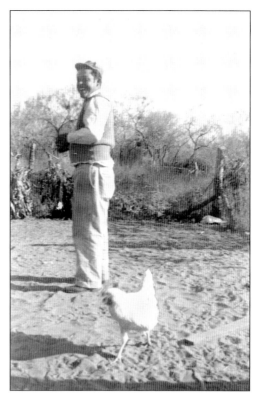

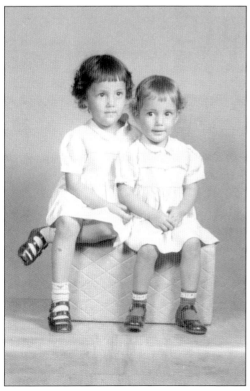

Mary Felix Rodriguez and Eloise Rodriguez pose for the only studio photograph taken of the sisters in 1952. They are the daughters of Felix and Ramona (Tijerina) Rodriguez. (Courtesy of Eloise Rodriguez.)

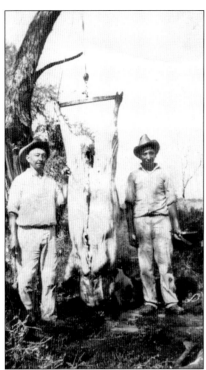

Jose Simon Rodriguez and his friend Señor Salazar are butchering a hog for tamales and winter family use in November 1946. The tradition of butchering hogs in the wintertime goes back generations. The families used the meat of the hog to last for a few weeks during the hard winter months. The practice involved extended family, and everyone involved had a specific task. (Courtesy of Eloise Rodriguez.)

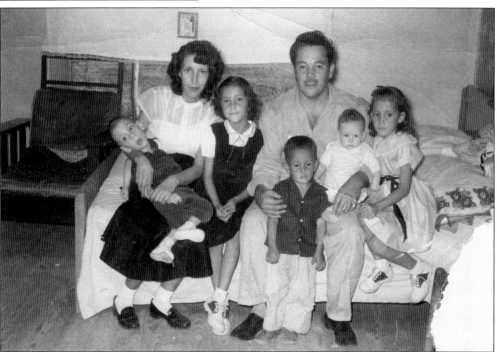

Pictured in February 1956 in this family photograph are Ramona and Felix Rodriguez with their children, from left to right, Joe Luis, Mary Felix, Adolfo, Rudy, and Eloise Rodriguez at their home in Pleasanton. The family farmed outside of the city of Pleasanton in rural Atascosa County. (Courtesy of Eloise Rodriguez.)

The First Festival always draws crowds to Atascosa County. Shown here is the first Pleasanton Cowboy Homecoming parade in 1966. Pictured are Bruce Warden, Joe "Bimbo" Zepeda, Norman Porter Jr., and Randy Zidek. (Courtesy of Norman Porter Jr.)

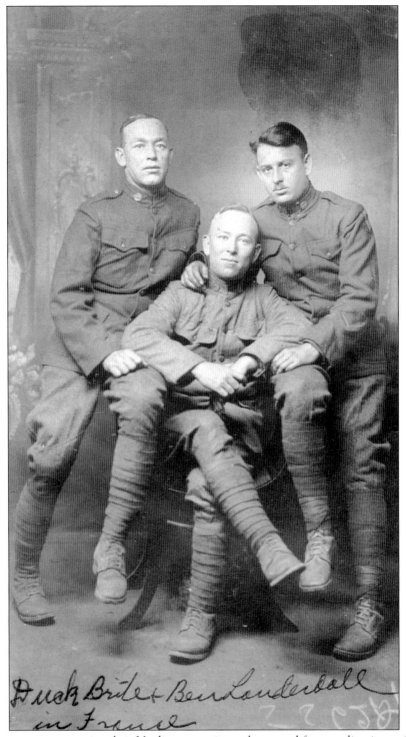

These boys were representing their Verdi community as they posed for a studio picture in France during World War I. They also represent a long line of Atascosa County families. They are, from left to right, Jim Brite, Duck Brite, and Ben Lauderdale. (Courtesy of Norman Porter Jr.)

Sitting for a photograph studio picture in 1948 are, from left to right, Betty (Keys) Young and Norma Fay Vickers. In a standing family photograph are, from left to right, sisters Nora (Keys) Eichman, Ellen (Keys) Van Cleave, Lola (Keys) Galbreath, and Betty (Keys) Young in 1938. (Both, courtesy of Betty Keys Young.)

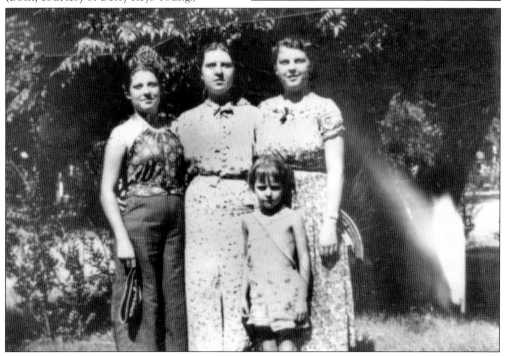

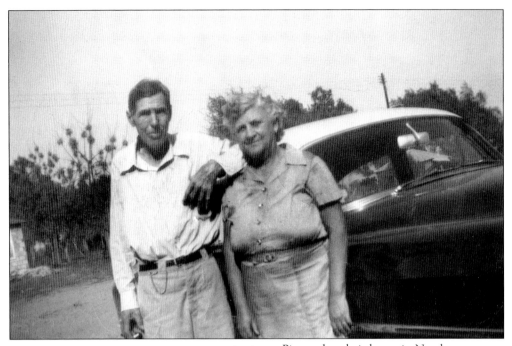

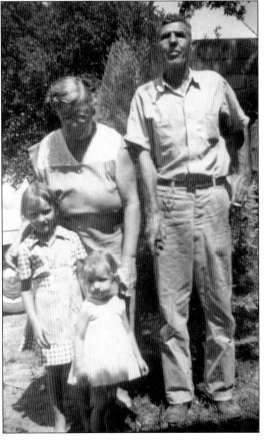

Pictured at their home in North Pleasanton are Kenneth Keys and his wife, Vivian. North Pleasanton was incorporated with Pleasanton in 1961. Prior to 1961, North Pleasanton was home to the San Antonio, Uvalde & Gulf Railroad station. The Keys family resided near the railroad station and the local ice plant. Neither of those buildings remain today. (Both, courtesy of Betty Keys Young.)

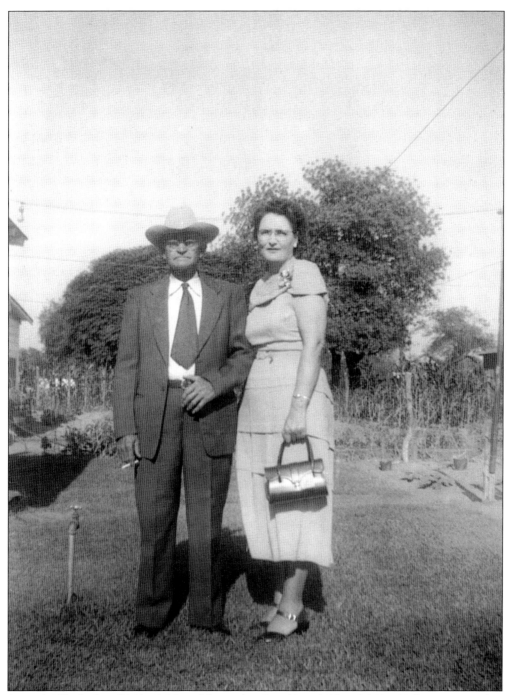

Samuel Alfred Blair (1888–1956) and his wife, Mary (Gates) Blair (1912–1997), are pictured at their home in Pleasanton, Texas. They were married in 1936 in Concho County, Texas. Samuel served as the local city marshal in Pleasanton during the 1940s and 1950s. Mary Gates's family was pioneers of Atascosa County, settling in the Poteet area in the 1860s. Several communities and towns were built by the Gates brothers, Abner Valentine Gates and William Norwood Gates. (Courtesy of Leigh Ann Blair-Gonzales.)

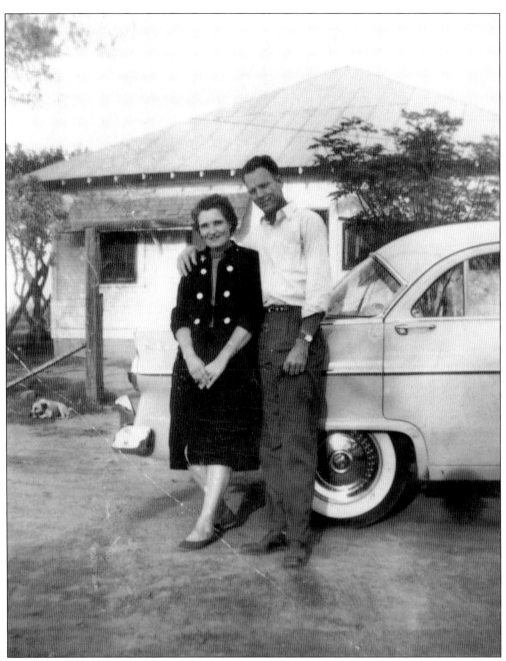

Mary Gates and her second husband, Leon Maxwell (1922–2004), are seen in Pleasanton, Texas. Mary Gates married Leon Maxwell in 1957. Leon was a resident of Pleasanton where he resided until his passing. Leon's parents lived in a home in what was then known as North Pleasanton. Today, Pleasanton encompasses both sections (north and south) as one city. (Courtesy of Leigh Ann Blair-Gonzales.)

Bill Lee Blair and his mother, Mary (Gates) Maxwell, are pictured June 1960 on Bill's wedding day. Bill was the son of Samuel Blair and Mary Gates. Bill resided in Pleasanton with his wife, Diana Ewing, where they raised a daughter Leigh Ann. They remained citizens of Atascosa County for the entirety of their lives. (Courtesy of Leigh Ann Blair-Gonzales.)

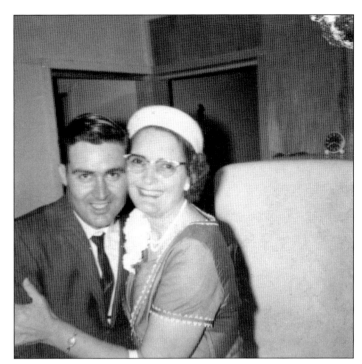

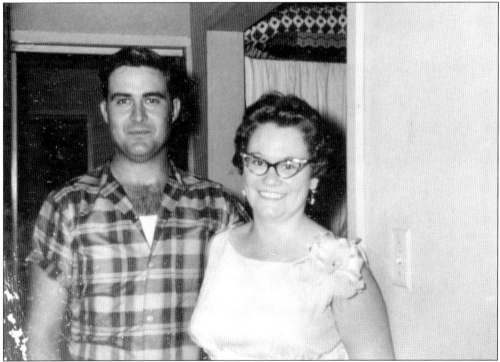

Pictured are Bill Blair and his wife, Diana (Ewing) Blair, in October 1960. The two were wed in June 1960. Bill worked in both the oil and ranching industries during his lifetime. However, he credited his start in life to his time working at Williams Hardware store. Diana pledged her career to the Pleasanton First Baptist Child Development Center. (Courtesy of Leigh Ann Blair-Gonzales.)

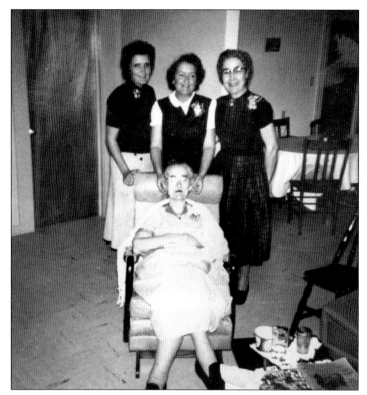

At left, Mary (Gates) Maxwell, Lena (Gates) Koehler, and Clara (Gates) Flowers are seen with their mother, Cora Sylvana (Troutz) Gates, in January 1959. Cora Gates was born to a German/Scottish family in the Poteet area. Her grandfather, a German immigrant from Baden, Germany, was involved in the Santa Fe Expedition. Below, Clara (Gates) Flowers and Mary (Gates) Maxwell are pictured in Clara's home in Pleasanton in March 1972. (Both, courtesy of Leigh Ann Blair-Gonzales.)

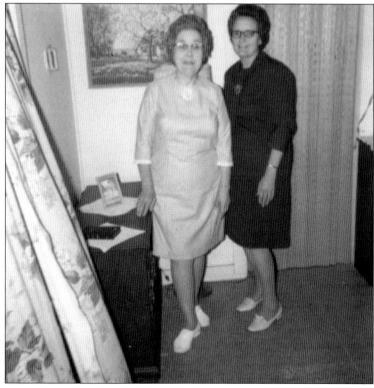

# Two

# POTEET

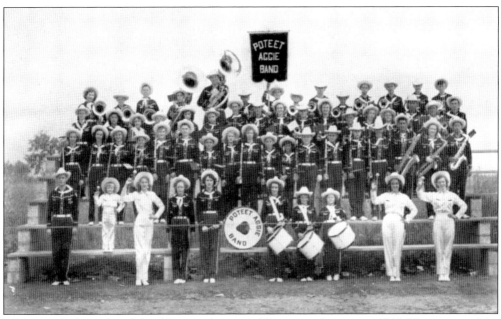

The Poteet Independent School District has served Poteet residents since 1913. The origins of the Poteet Independent School District began with a humble start in the Gates Valley Church, which was also used as a school. The district utilized the Aggie mascot as Poteet has always been a rural community with farming and agriculture at its core of operation. The nearby Shiloh Community also has ties to Poteet as the Poteet Independent School District encompassed two schoolhouses at the turn of the 20th century. (Courtesy of the Franklin family.)

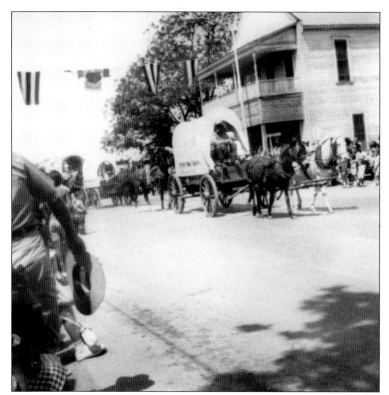

The Cannon Hotel in Poteet, Texas, is shown during a Poteet Strawberry Festival parade in 1960. After it was no longer used, the hotel building was demolished in the 1970s. Parades celebrating the annual Poteet Strawberry Festival are a colorful event. Floats and entries such as the one pictured here are a feature attraction. (Courtesy of Richard Franklin.)

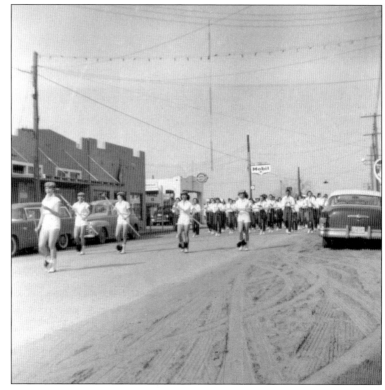

The Poteet twirlers and Aggie band are on display in the Poteet Strawberry Festival parade. (Courtesy of Barbara Franklin.)

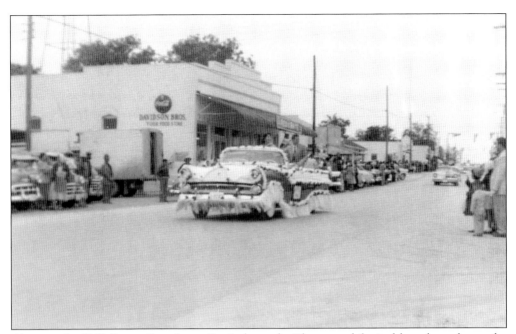

Above is the 1957 Poteet Strawberry Festival parade. The annual festival has always boasted a Saturday morning parade. The parade route has not changed much throughout the years and has been a staple of the annual festival since 1948. The first parades featured farm trucks, old cars, musicians of all music types, and local flavor. (Both, courtesy of Barbara Franklin.)

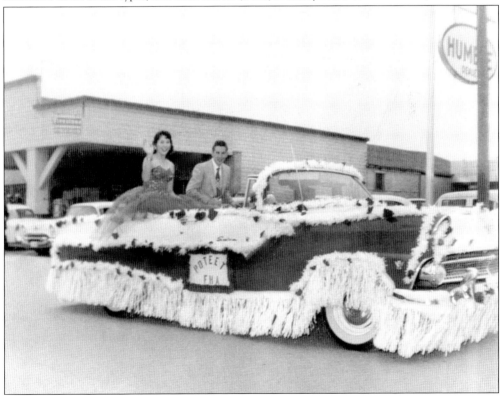

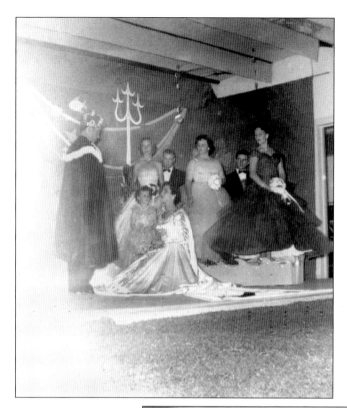

Pictured is the Poteet Strawberry Festival court coronation in April 1956. The coronation event has annually been a celebrated event and is held before the Poteet Strawberry Festival. (Courtesy of Barbara Franklin.)

The Poteet Strawberry Festival court is shown preparing for coronation in April 1953. The Poteet Strawberry Festival is an annual event that began in 1948 as an effort to get returning World War II veterans back to the farm. Today, the festival hosts thousands to the small city for one weekend in April. (Courtesy of Barbara Franklin.)

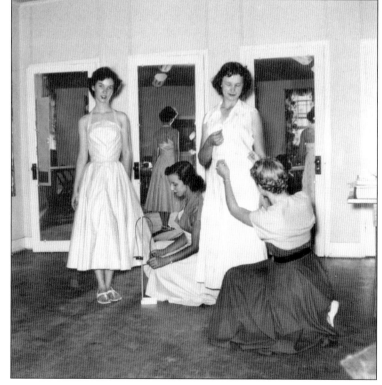

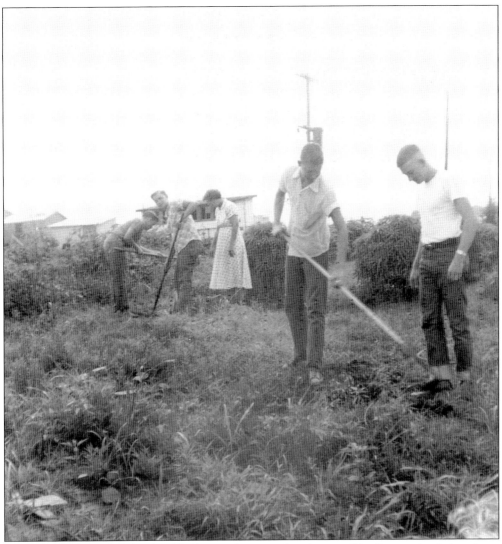
In April 1953, Poteet High School had a strawberry garden clean up. The Poteet schools have been a proponent to the local flavor and agriculture of the past. The local horticulture and plant sciences give local students a link to the city's successful past. (Courtesy of Barbara Franklin.)

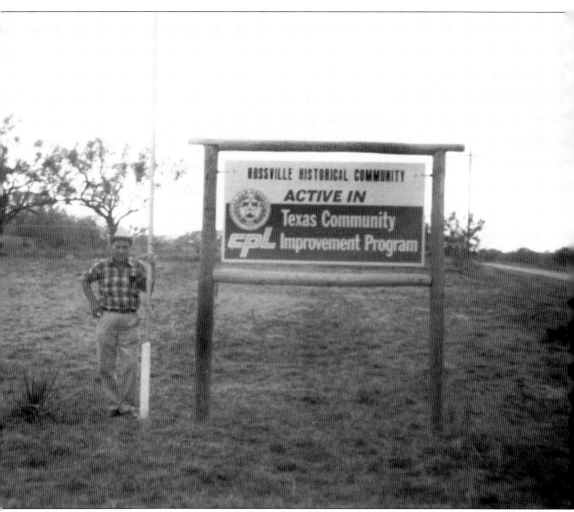

Roy Martinez (1913–1995) stands in front of the Rossville Community Center. Martinez began a successful nursery business in 1943 near Poteet in an unincorporated community known as Rossville. Rossville was founded by John and his brother W.F.M. Ross in 1873. A post office was established at Rossville in 1887 and remained in operation until 1947. Today, Roy's Nursery has been owned and operated by the Martinez family (Roy's sons) for almost 80 years. (Courtesy of Robert Martinez.)

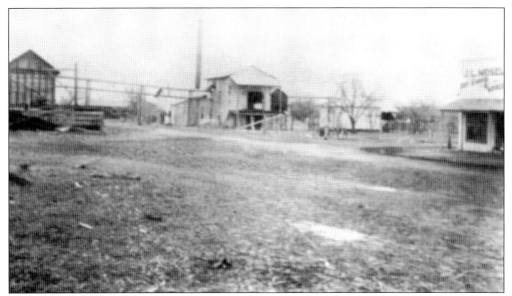
The J.C. Moseley Store is pictured in downtown Poteet. The year of the photograph is unknown. (Courtesy of Connie Waxler.)

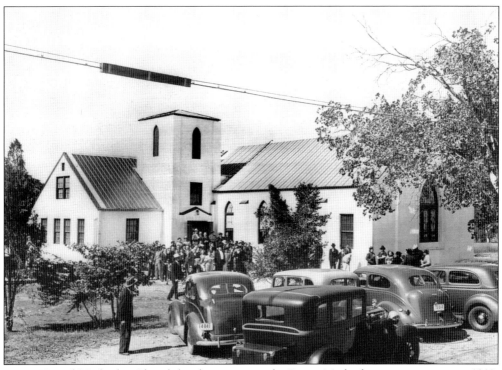
Poteet United Methodist Church has been serving the Poteet Methodist community since 1912. Land was donated by the Poteet Townsite Company, and a new church was built in 1937 and dedicated in 1940. This church continues to host services today and has the biggest congregation to date. (Courtesy of Pastor David Collett.)

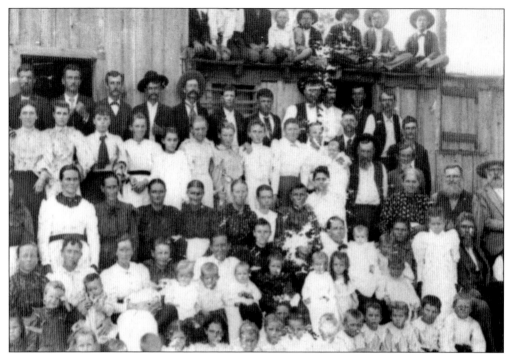

Poteet community residents gather for a photograph in 1891. This photograph would have been during the period prior to the townsite when it was a loosely organized community with dwellings and basic services. (Courtesy of Connie Waxler.)

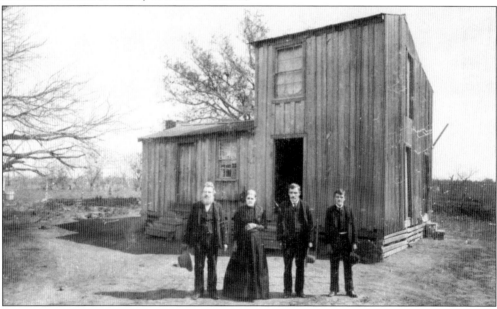

Francis Marion Poteet with his wife, Mary Ann, and two of his sons are pictured in the late 1800s. The town of Poteet was named after him for his contributions. F.M. Poteet served as postmaster and was a prominent businessman, farmer, pioneer, and former Army scout. He served during the Civil War, returning to Atascosa County and establishing a residence that would lead to the area becoming known as Poteet thereafter. (Courtesy of Richard Franklin.)

Page's Dry Goods Store is pictured here in 1948. The store was located at the intersection of Avenue H and Fifth Street in downtown Poteet. Pictured are a Mrs. Blackburn and Elton and Cora Page. The department store transitioned from a dry goods store to a department store that sold shoes, clothing, and seasonal items. (Courtesy of Connie Waxler.)

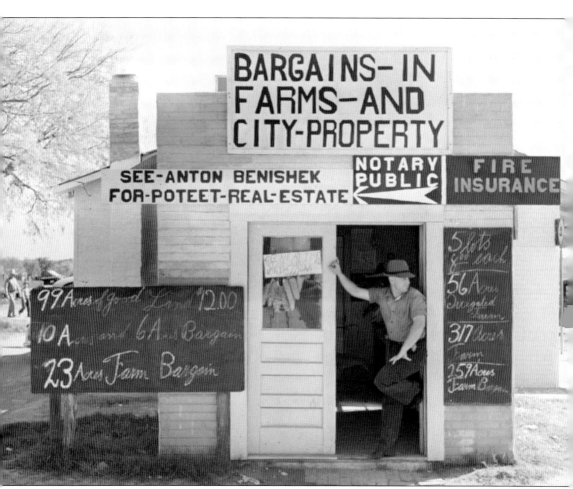

Anton Benishek Jr. (1915–1984) was the son of European, immigrant parents. Anton and his father were both local entrepreneurs who specialized in real estate. Anton Jr. married Josephine Parise in 1939 and continued the family work habits. Anton and Josephine also owned and operated a local café early in their marriage. (Courtesy of the Atascosa County Historical Commission.)

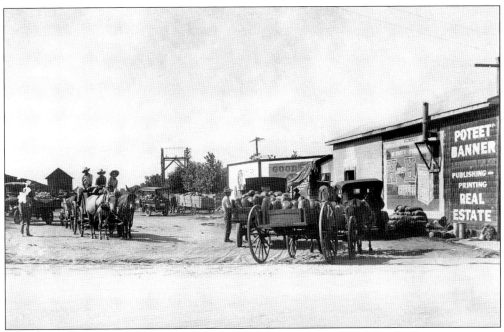

This view of downtown Poteet in 1912 was taken prior to the fire in 1913. The fire was a turning point for the city of Poteet and caused damages worth $50,000 to seven major businesses, including the local newspaper press, the *Poteet Register*. (Courtesy of Connie Waxler.)

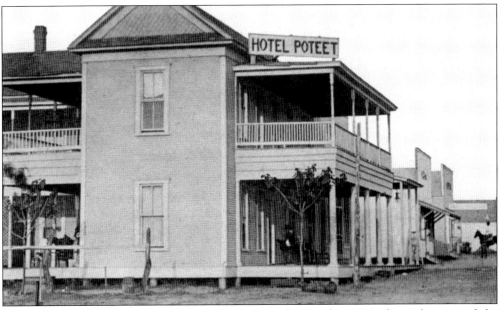

Hotel Poteet is pictured above in 1912. The hotel was destroyed in 1913 when a fire ravaged the town and destroyed numerous buildings in downtown Poteet. (Courtesy of Connie Waxler.)

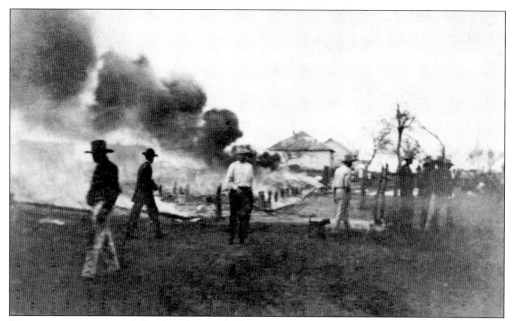

Poteet citizens surveyed the fire that took their town in 1913. As one can see, the buildings and remnants of the town are still smoldering. The seven businesses destroyed during this time were Poteet Mercantile Company, Musgrave & Young's furniture store, Hotel Poteet, J.G. Smith confectionery, J.G. Rodriguez Drug Store, an office building and millinery store, and the *Poteet Register*. (Courtesy of Connie Waxler.)

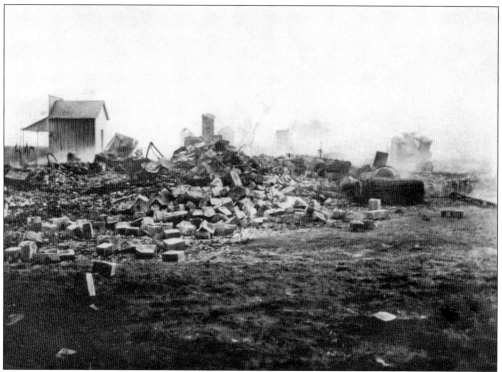

Pictured above are the remains of Hotel Poteet in 1913 after the fire. (Courtesy of Connie Waxler.)

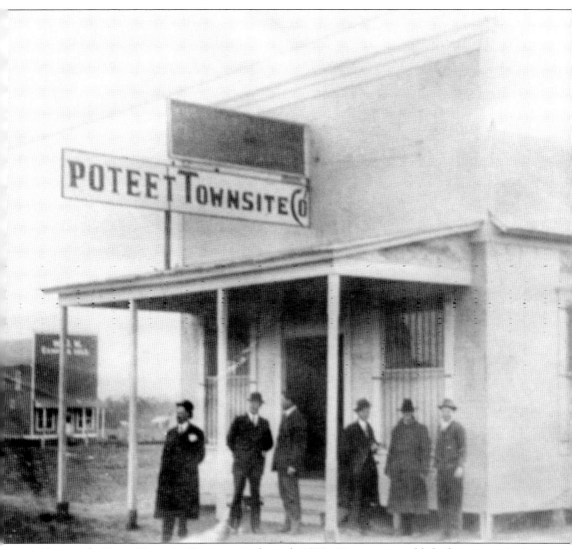

Above is the Poteet Townsite Company in the early 1900s. Poteet was established as a townsite in 1911 and incorporated officially in 1926. Since the area had been referred to as Poteet as a result of the early mail service, the new town was named in honor of Francis Marion Poteet. (Courtesy of Connie Waxler.)

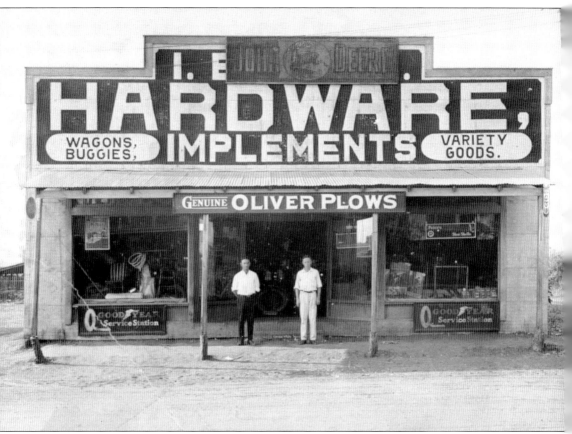

Crouch's Store operated from 1924 to 1986. It was owned and operated initially by O.G. Barrow, then O.N. Crouch and his son Bryan Crouch. The store began as a general store that provided goods to the local community. Toward the end of the store's operation, it was a department store that provided quality clothing (dress and Western wear). The store was once the only place to have one's hat shaped by O.N. Crouch himself. Today, the building still stands and serves as the current city hall for the city of Poteet. (Courtesy of Bryan Crouch.)

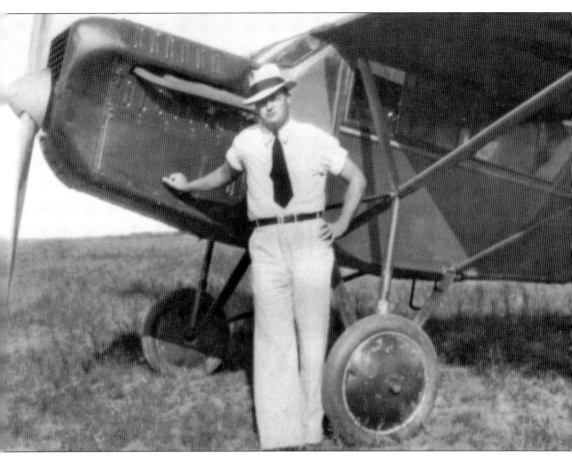

John Carroll Lott is pictured in the early 1940s as he leans on his Curtis-Robin Airplane. Lott (1908–1981) was a longtime airplane enthusiast and was proud of his planes. He flew his planes until the late 1970s and was well known for his hobby. (Courtesy of Jean Lott Crouch.)

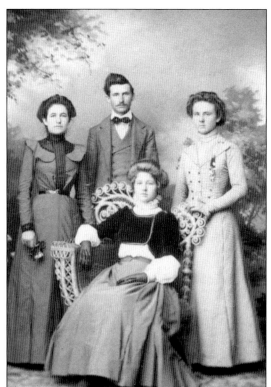

Rose Jones stands at far left in the photograph accompanied by her brother Abner Jones, right, and two unidentified friends of the family. Rose and Abner's parents, Vandiver and Canzada Jones, were early settlers in the Shiloh community of Atascosa County. Rose would eventually become Rose Meyer after marrying George Meyer some years later. This photograph was taken in approximately 1900. (Courtesy of Janet Collums Bartek.)

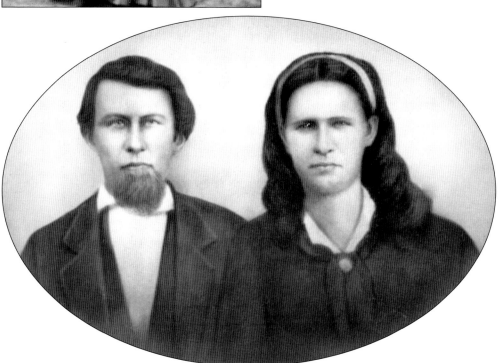

Vandiver Stewart Jones and his wife, Canzada (Stroud) Jones, were the parents of Rose Jones and Abner Jones. (Courtesy of Janet Collums Bartek.)

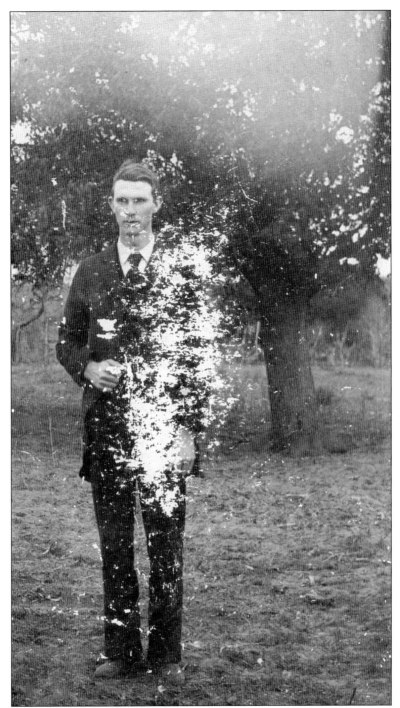

Richmond (sometimes called Richmon) Jones poses for a photograph in the Shiloh community. Shiloh was a community that existed until the early 1900s between modern-day Leming and Poteet, Texas. Richmond's family settled in Shiloh and consisted of his father, Vandiver Stewart "V.S." Jones; his mother, Canzada Stroud; and his siblings Abner, Frank, and Rose (Jones) Meyer. (Courtesy of Janet Collums Bartek.)

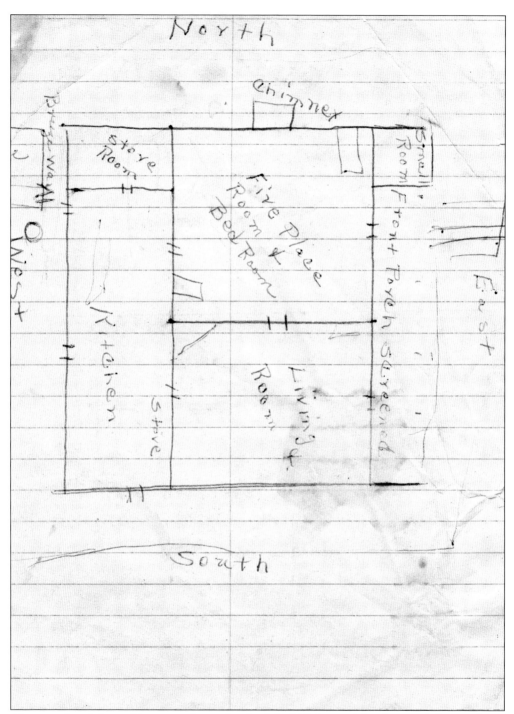

Above are hand drawn blueprints for a cabin built by V.S. Jones. After leaving Arkansas, Jones and his wife, Canzada, settled in Shiloh. There, a cabin was built, and a family was raised. Today, the property is still owned by V.S and Canzada Jones's descendants. Although the cabin no longer stands, their descendants have built a family home there. (Courtesy of Janet Collums Bartek and JoAnn Collums Moseley.)

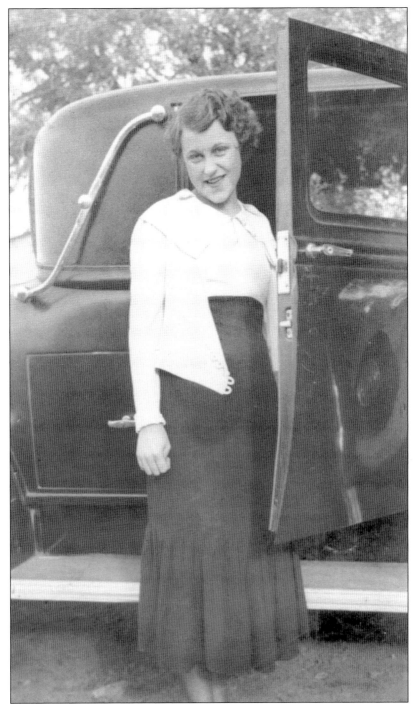

Glennie Meyer stands in front of a new car. She was born to George and Rose Meyer in 1911. Glennie passed away in 2002 at the age of 90. Her family pioneered the area of Atascosa County now known as the Shiloh community, a ghost town today. The settlers and inhabitants of Shiloh have called Poteet their home and their nearest city. Glennie Meyer's family continues to maintain a historic role in the family's existence. (Courtesy of Janet Collums Bartek.)

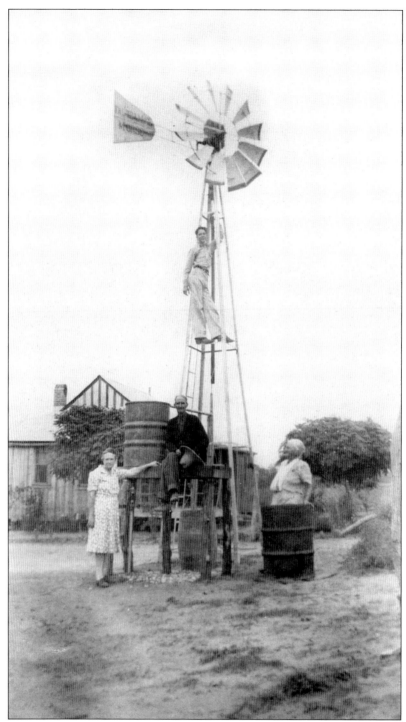
Harriet and Don Williams and Rose (Jones) Meyer watch as a young man climbs the windmill. This scene was common in rural Atascosa County where windmills were used in everyday life from homestead to farm, many times of which they were one in the same. (Courtesy of Janet Collums Bartek.)

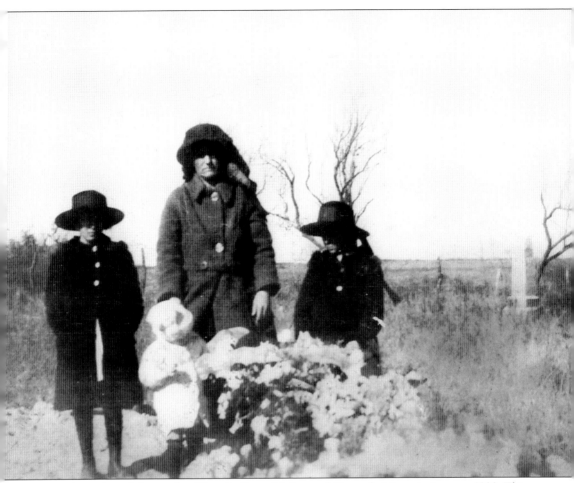

Pictured are, from left to right, Glennie, Rose, Melba, and Canzada Meyer in January 1923. This photograph was taken at George Meyer's funeral at Shiloh Cemetery in 1923. Today, Shiloh Cemetery is historically recognized by the Texas Historical Commission and is well maintained by descendants of the deceased. George was married to Rose, and their marriage produced Glennie, Melba, and Canzada. He passed away at the age of 47. (Both, courtesy of Janet Collums Bartek.)

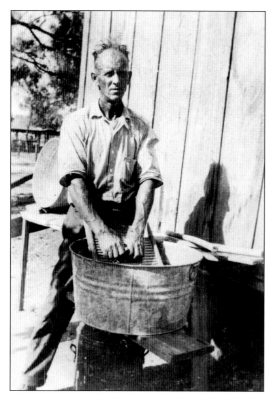
George Meyer does laundry on a washboard in 1922. Meyer passed away at the age of 47 from natural causes in Mirando City, Texas. He was married to Rose Jones, and with her, he had three daughters, Glennie, Melba, and Canzada. (Courtesy of Janet Collums Bartek.)

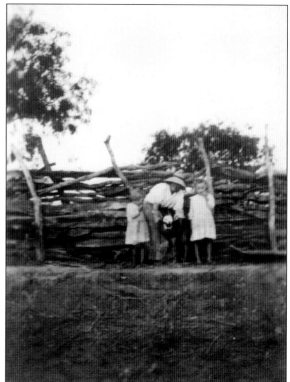
Pictured are, from left to right, Melba, Rosie, and Glennie Meyer posing with the farm's newest calf in 1919. The children's parents were Rosie (Jones) Meyer and George Meyer. (Courtesy of Janet Collums Bartek.)

At right, Glennie Meyer attended a country music event in 1936 at San Antonio. Below, she is shown standing in front of a new car in 1936. Meyer attended music performances in the San Antonio area. She was a fan of the swing era of country music. (Both, courtesy of Janet (Collums) Bartek.)

Walker Williams was an avid equestrian as was his family. The Williams family was prominent in the Poteet area. They also resided in the Gates Valley community, a ghost town now, about three miles north of Poteet. Walker (1899–1974) was born in 1899 to George and Anna (Matthews) Williams. He married Miriam Wilson, and their union produced Wanda Fay, Mary Ida, and George. (Both, courtesy of Janet Collums Bartek and JoAnn Collums Moseley.)

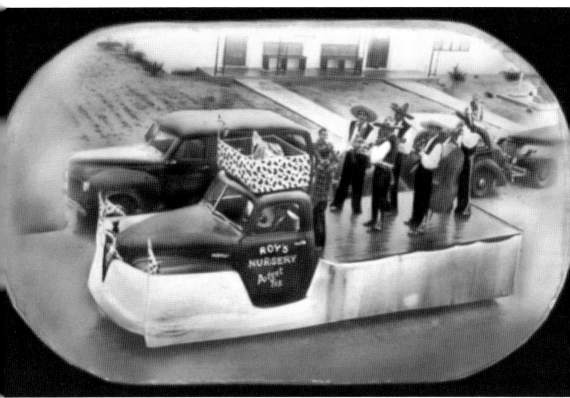

Pictured is the Roy's Nursery Truck in the First Poteet Strawberry Festival Parade in 1948. The truck is decorated as a float as the band of Raul "Roy" Martinez plays on the bed of the truck dressed in the style of mariachi. Roy's nursery has been in business in rural Poteet since 1942 and is one of the longest operating businesses in the county. Today, the business still operates under the management of Roy's son Ruben, and the Martinez family is instrumental in Poteet's Agricultural success. (Courtesy of the Roy Martinez family.)

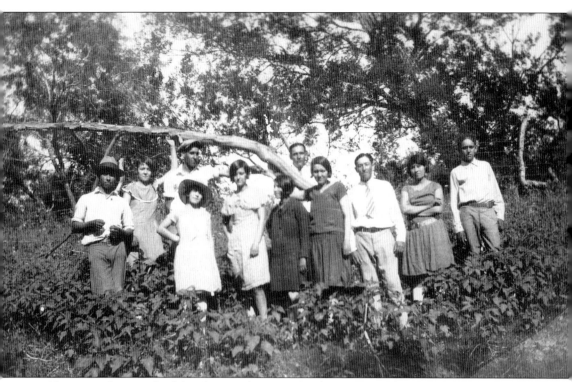

Above is a photograph of the Flores and Lozano families in 1936. These families settled the area just north of modern-day Poteet. Pictured are, from left to right, Jose Maria Flores, Beatriz Lozano, Estela Flores, Nellie Lozano, Teresa Flores, Florinda Lozano, Alberto Flores, Romana "Ruby" Flores, and Ernesto Lozano. (Courtesy of Rebecca Olivares Flores.)

Herminia (Olivares) Flores and Jose Maria Flores are pictured here in 1945. They were both born in Atascosa County. Jose served in the Army, 628th Field Artillery Battalion, from April 1944 to September 1945. Herminia remained on their homestead, north of Poteet, to raise their children and continue the operation of the farm. Their farmhouse had no modern utilities, and Herminia used a wood-burning stove to assist with her daily duties. (Courtesy of Rebecca Olivares Flores.)

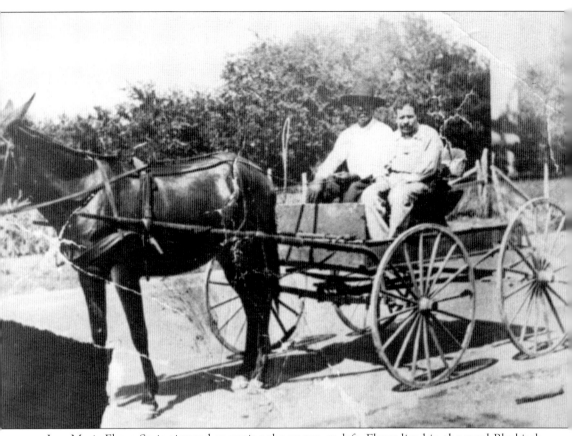
Jose Maria Flores Sr. is pictured operating the wagon on left. Flores lived in the rural Blackjack area northeast of Atascosa County. He was married to Tomasa Reyes. (Courtesy of Rebecca Olivares Flores.)

This photograph of Tomasa (Reyes) Flores was taken professionally. Flores was born in San Antonio in March 1849. Tomasa and Jose Maria Flores' marriage produced a son, Jose Maria Flores Jr., on July 30, 1873. (Courtesy of Rebecca Olivares Flores.)

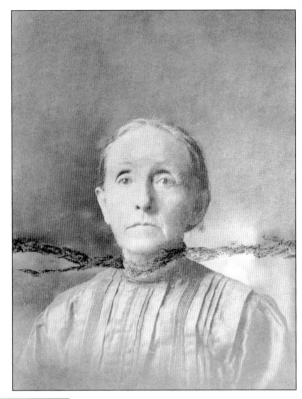

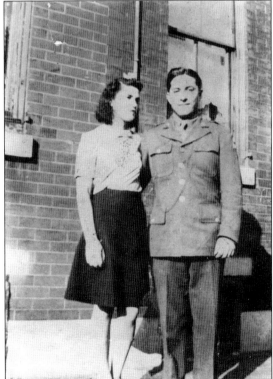

Johnnie W. Flores was born in Atascosa County on December 10, 1910. He died on December 12, 1944, during the Battle of the Bulge. Pfc. Johnnie Flores served in Company B, 36th Armored Infantry Regiment. He is a posthumous Purple Heart recipient. (Courtesy of Rebecca Olivares Flores.)

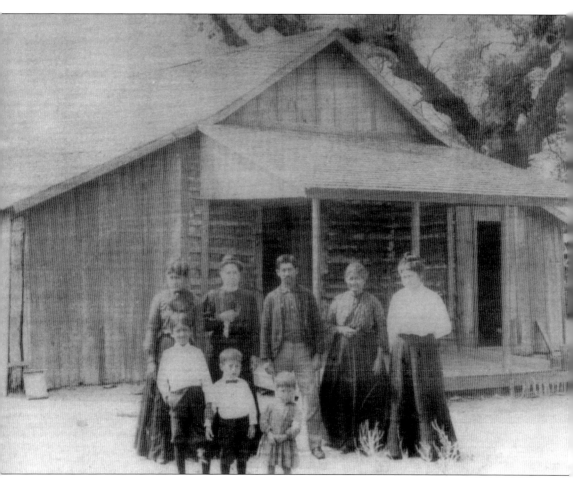

Pictured in front of their home are, from left to right, (first row) Felipe C. Reyes, Andres Lambert Curvier, and Eloy Ramon Curvier; (second row) Maria Curvier, Trinidad (De La Cerda) Curvier, Andres Curvier, Eulogia de Los Santoscoy Salas, and Vicenta Salas. Eulogia was the mother of Andres, Vicente, and Maria. The rest are grandchildren with the exception of Trinidad, who is Eulogia's daughter-in-law. (Courtesy of Rebecca Olivares Flores.)

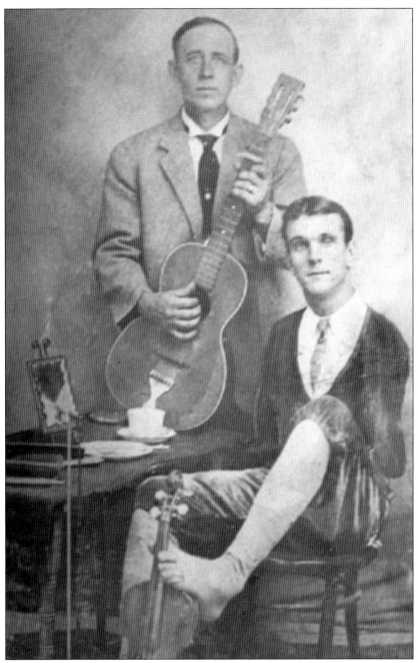

Paul Desmuke was born in Amphion in 1876. He once served as a justice of the peace in Atascosa County. His notoriety came from his lack of arms; he was dubbed "The Armless Wonder." Besides serving as a justice of the peace, he appeared with Ripley's Odditorium, where he threw butcher knives within one inch of his wife, who stood seven feet away. A marriage record photograph published in the Atascosa County sesquicentennial book shows a document signed by Judge Desmuke that reads, "Witness my hand foot this 14th day of November 1904." The word "hand" was stricken by Judge Desmuke and replaced with the word "foot." Judge Desmuke and his wife, Mae, are both interred at the Jourdanton City Cemetery. (Courtesy of the Leon Zabava Collection.)

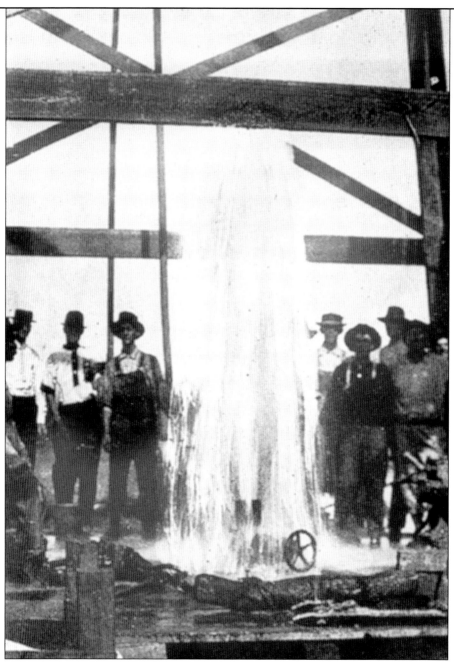

Henry T. Mumme (1870-1947) offered postal service as postmaster at his store. In 1910, he and his wife, Ida (1869-1942), donated 300 acres of land for a new townsite. Since the area had been referred to as Poteet as a result of the early mail service, the new town was named in honor of Francis Marion Poteet. Mumme moved his store to the new townsite in 1911. He drilled the town's first artesian water well and is credited with introducing the cultivation of strawberries here. The artesian water, together with the sandy soil of the region, proved ideal for growing the berries. Known statewide for its superior quality strawberries, Poteet has been nicknamed the "Strawberry Capital of Texas." (Courtesy of the Atascosa County Historical Commission.)

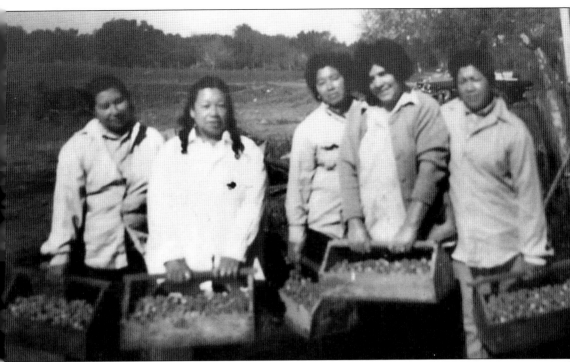

Strawberry pickers show a portion of their labor for the day in Poteet in 1974. These ladies often worked as a "woman only" crew. They traveled throughout the area depending on the crops that needed human labor to harvest them. Pictured are, from left to right, Candelaria Ybarra, Genoveva Ybarra, Francisca (Ybarra) Davila, Alicia Orta, and Josefa Ybarra. They were all sisters with the exception of their family friend, Alicia Orta. (Courtesy of Leigh Ann Blair-Gonzales.)

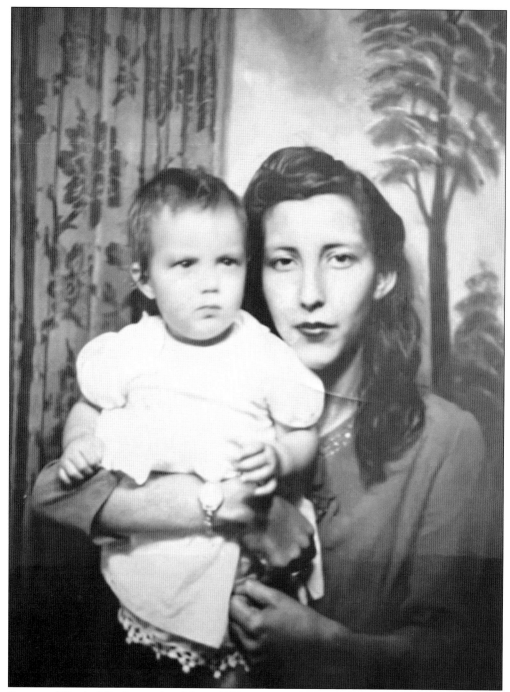

Ramona (Tijerina) Rodriguez lived from 1931 to 1995. The oldest daughter of Juan and Rosaura Tijerina, she is pictured here holding her daughter Mary Felix Rodriguez. Ramona Tijerina married Felix Garcia Rodriguez in 1948, and they had eight children. They moved to Rodriguez Ranch in Pleasanton where they raised their family. (Courtesy of Eloise Rodriguez Garza.)

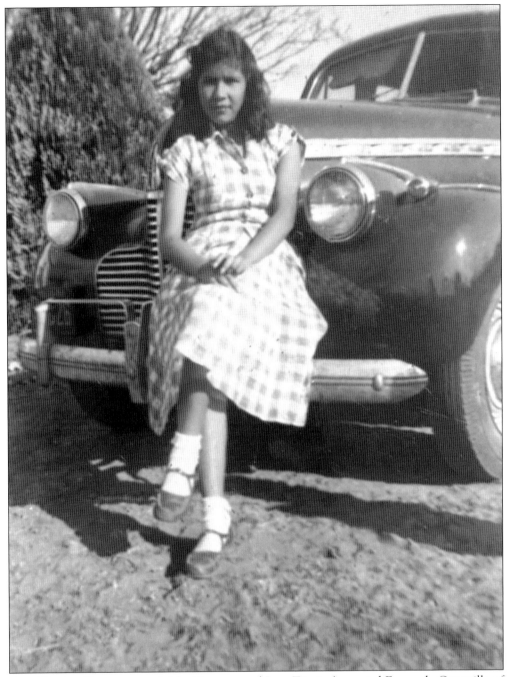

Goya Tijerina (the youngest child of Rosaura and Juan Tijerina) married Fernando Camarillo of Poteet. They moved to Arizona where they raised their children. (Courtesy of Eloise Rodriguez Garza.)

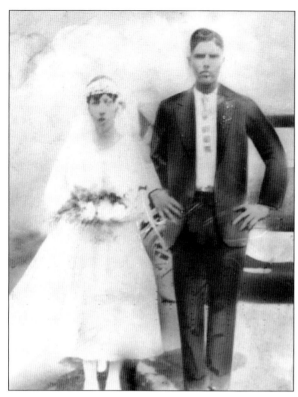

The left photograph depicts Rosaura Vasquez (1911–1991) and Juan Tijerina (1911–1953) when they were married in 1930. Rosaura and Juan Guerra Tijerina lived and raised their family in Poteet. They had five children, Ramona, Jesus, Julian, Juan, and Goya. In 1953, Juan was in a fatal car accident coming back from a trip to Laredo. (Both, courtesy of Eloise Rodriguez Garza.)

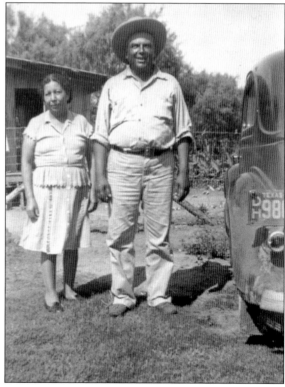

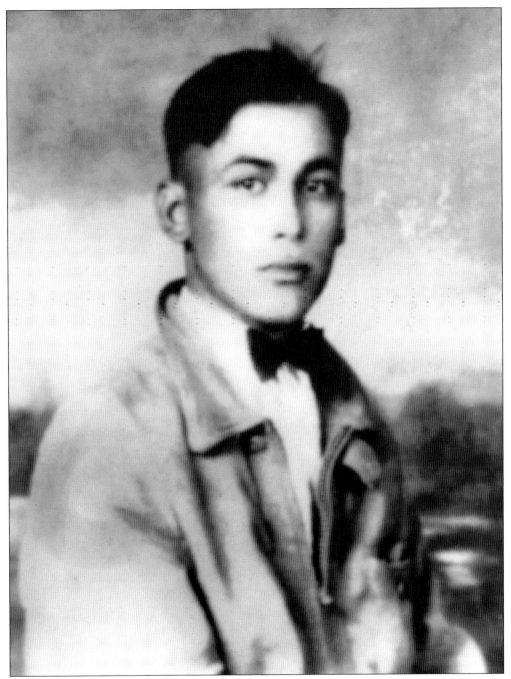

Eduardo Estrada Garcia was the son of Juan Archuleta Garcia and Dominga (Estrada) Garcia. He married Ciria Paula Nañez and had 13 children: Adelita, Catarina, Dominga, Jose Antonio Guadalupe, Margarita, Isabel, Paula, Victoria, Manuela, Eduardo, Josefa, Gloria, and Delia. He also came from a long line of siblings: Ignacio, Lino, Jose Maria, Maria Dominga, Juan, Valentin, Leandro, Maria Concepcion, Maria de Jesus, Francisco, Clemente, and Federico. (Courtesy of Cheryl Briseño Garcia.)

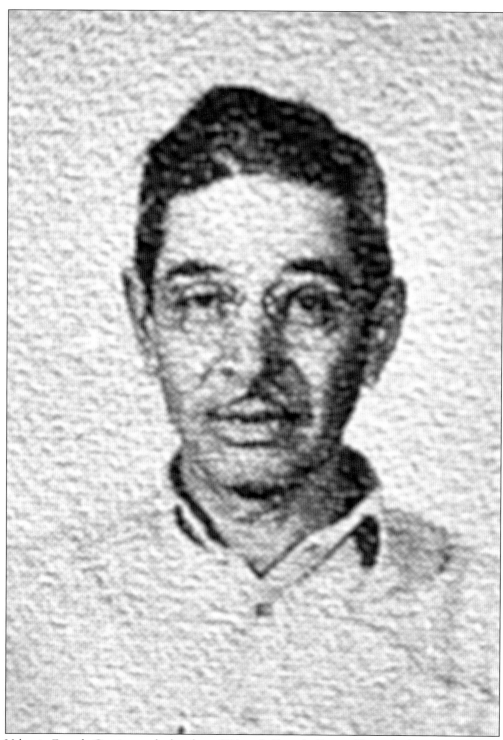
Valentin Estrada Garcia was the brother of Eduardo Estrada Garcia. He worked as maintenance/custodial personnel for the Poteet Independent School District for many years, contributing to the health and safety of many young Poteet citizens. (Courtesy of Cheryl Briseño Garcia.)

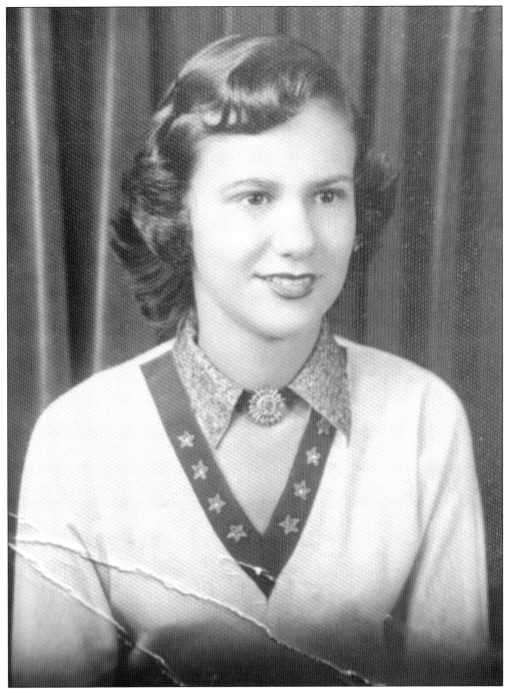

Senobia Archuleta Flores was the niece of one of the original settlers to Atascosa. The Archuleta family hails from Paseo del Norte (El Paso) and came with Ignacio Contis Garcia when he received a land grant to settle in the county. His wife, Maria de Jesus Archuleta, and her family originally settled in present-day Losoya. She helped create the community around Mission Medina, El Carmen, and Mount Carmel before marrying her husband and moving to Atascosa County. (Courtesy of Cheryl Briseño Garcia.)

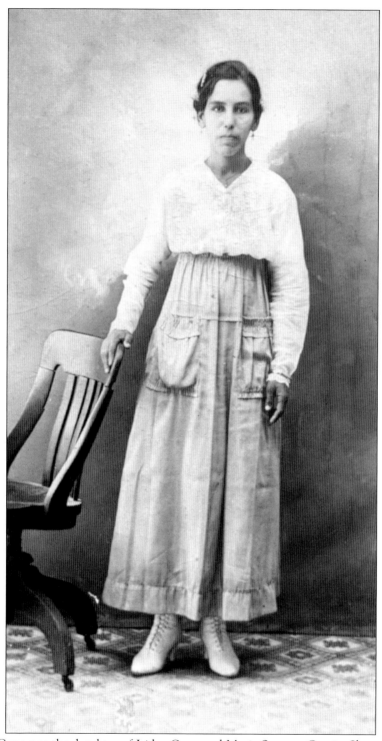

Consuelo Cano was the daughter of Isidro Cano and Maria Socorro Garcia. She married Jose "Joe" Huron Sr. and had four children: Manuel, Roy, Daniel, and Joey. Consuelo's siblings were Rosendo and Ofilia. (Courtesy of Cheryl Briseño Garcia.)

Abram Ramirez Garcia was born in the El Carmen community. He came to Atascosa County with his father, Victoriano Contis Garcia, and his uncle Ignacio Contis Garcia. Abram married Paula Cano and moved back to the El Carmen area to raise his children: Eloisa and Maria. His siblings were Victor, Juan, Jesus, Reymundo, Pedro, Mariela, Maria de la Cruz, Navaron, Maria Cayetana, Juana, and Gilberto. He is laid to rest at El Carmen. (Courtesy of Cheryl Briseño Garcia.)

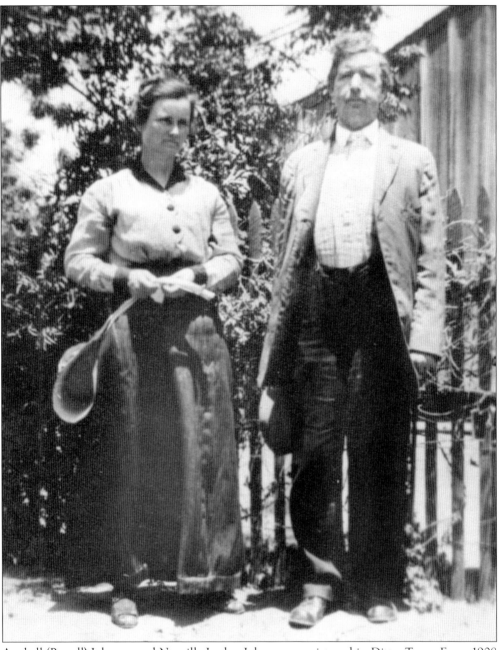
Anabell (Pascall) Johnson and Norville Jordan Johnson are pictured in Ditto, Texas. From 1908 to 1918, the couple owned and operated a general store in Ditto, Texas. (Courtesy of Carol Johnson Reamer.)

# Three

# JOURDANTON

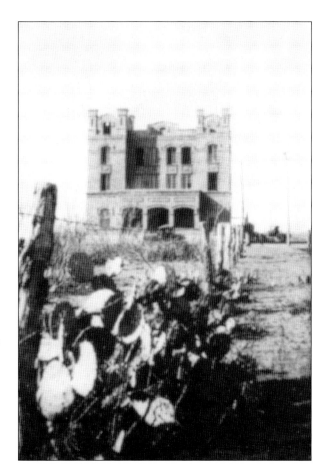

The Atascosa County jail is pictured in 1915. The county jail was built in 1915 to accommodate the new county seat in Jourdanton. The first floor housed living quarters for sheriffs and their families. The second and third floors housed specialized cells, with the second floor having a gallows room for executions. Although a gallows room was provided, the trapdoor was never used for that purpose. The jail was used from 1915 to 1982, when a new jail was built nearby. (Courtesy of the Jourdanton Community Library.)

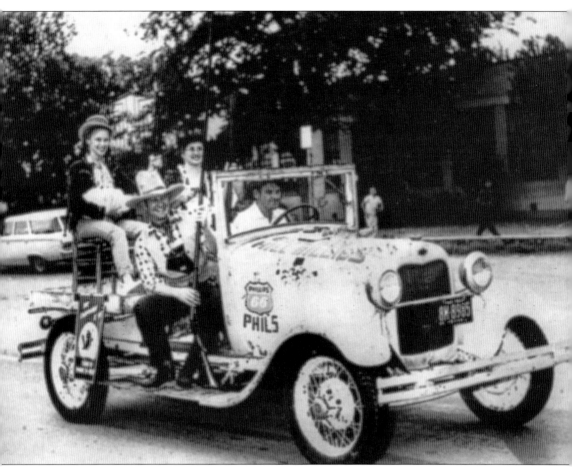

Here, the Ciomperlik family is representing Phil Ciomperlik's gas filling station in Jourdanton, Texas, during a parade. Ciomperlik used this vehicle as a prop at his station, during parades, and for special events. (Courtesy of the Jourdanton Community Library.)

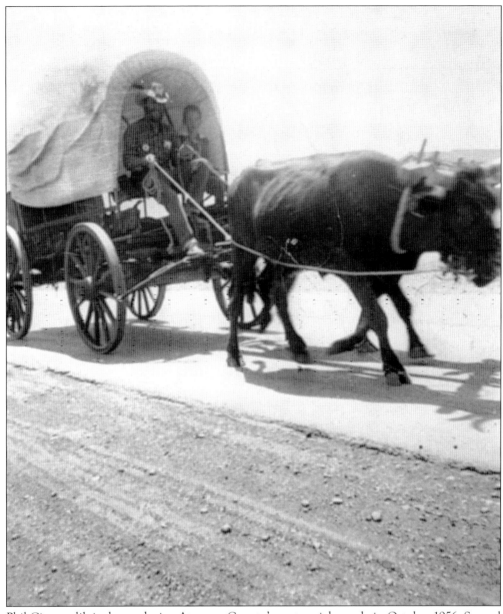

Phil Ciomperlik is shown during Atascosa County's centennial parade in October 1956. Several parades were held throughout the county during this time, and most folks went the extra mile to display their pioneer skills. (Courtesy of the Jourdanton Community Library.)

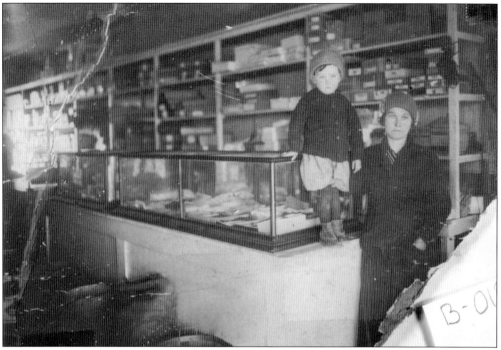

The Darby Store was owned and operated by D.T. and Alice Darby in downtown Jourdanton, Texas. Pictured above at the store counter is a young Marshall Darby and his mother, Alice Darby. This photograph was taken in 1924. (Courtesy of the Jourdanton Community Library.)

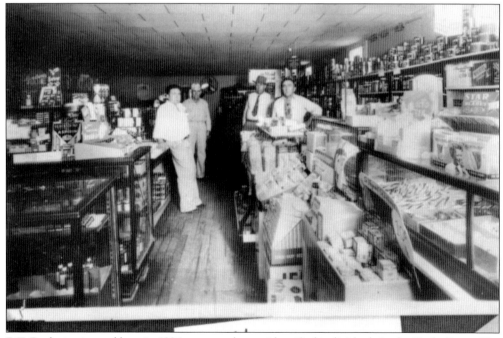

D.T. Darby is pictured here in 1924 among other unidentified individuals in the Darby Store. The Darby Store was a general store that carried over the counter medicines, household items, and food products. (Courtesy of the Jourdanton Community Library.)

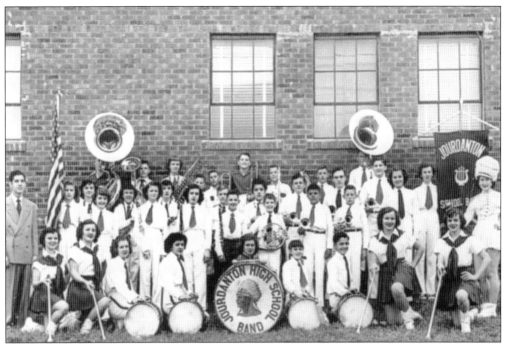

The Jourdanton High School marching band is pictured above in the 1950s. The Jourdanton Elementary School rhythm band is pictured below around 1939 or 1940. The Jourdanton Independent School District began in 1911, which was the first independent school district in Atascosa County and was recognized by the Texas Legislature. The school has been steeped in deep traditions and continues to grow today with the increasing population in Jourdanton. (Both, courtesy of the Jourdanton Community Library.)

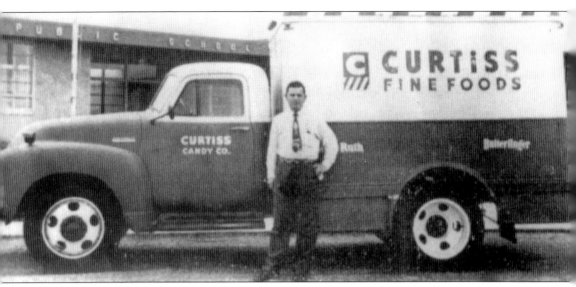

Martin Soward Jr. is pictured in 1954 in front of the Jourdanton Public School. Soward worked for the Curtiss Candy Company from 1949 to 1960 before going into bag candy sales and the vending machine business for himself. Note that the Curtiss truck proudly advertises Butterfinger and Baby Ruth candy bars. After leaving the Curtiss Candy Company, Soward continued to provide vending machines to local businesses and confectionary merchandise to local grocery stores for over 40 years. (Courtesy of Sheriff David Soward.)

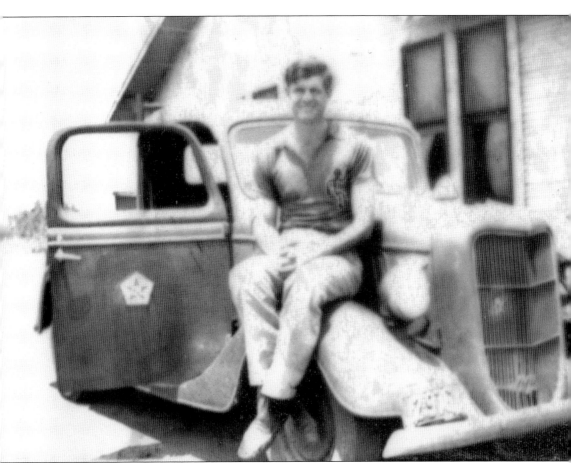

Wilber Porter Sr. is pictured in Jourdanton, Texas, in 1940. Porter served as the only lineman for the local Central Power and Light (CP&L) Company. Porter's shirt in the photograph displays the old CP&L logo. Linemen had tough jobs as they had to provide electricity at a time when the notion of electricity in the county was new. Porter's children recall how on stormy nights he would get up and wait for his phone to ring and then he would be gone for 24 hours or longer repairing and ensuring that the local residents had electricity. (Courtesy of Sheriff David Soward.)

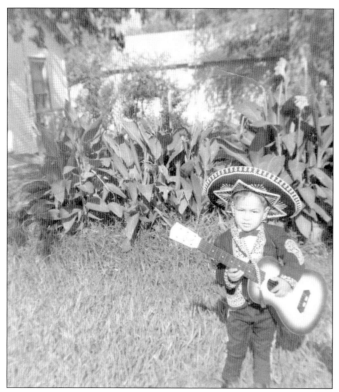

The Jourdanton H&H Hall once existed at what is now St. Matthew's Parish Hall. The H&H Hall building no longer stands, but its history is not forgotten by the Catholic parishioners. The hall hosted many events for the congregation of St. Matthew's Catholic Church. These photographs depict the celebration of Diez y Seiz de Septiembre in the 1960s. The Diez y Seiz celebration refers to September 16, the Mexican Independence Day. Hispanics still celebrate this event to remember their heritage as some can trace their family lineage to Mexico, where the date is commemorated annually. Pictured are Jose Saenz (left and below) and Gloria Cordova (below). (Both, courtesy of Hilda Amador Saenz.)

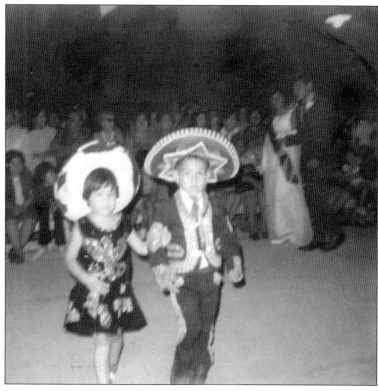

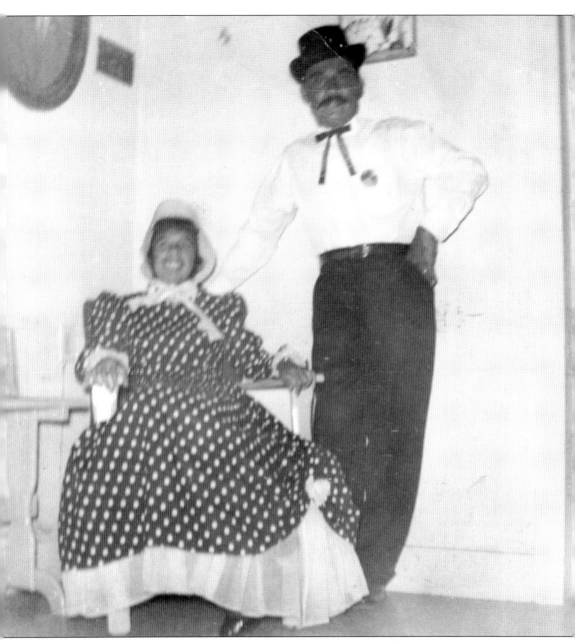

Pictured here are Eliborio Resendez Amador and his wife, Barbara (Garza) Amador. They, like many citizens, participated in the Atascosa County centennial celebration in October 1956. The event lasted three days, and the citizens were encouraged to attend in period dress of the mid-1800s. (Courtesy of Hilda Amador Saenz.)

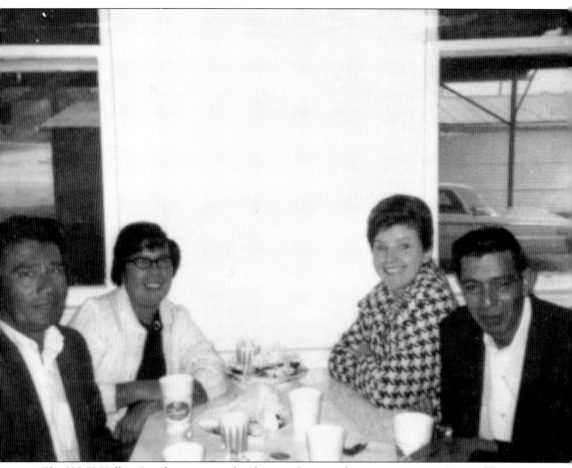

The H&H Hall in Jourdanton was a local venue for special events or parties. Pictured here are, from left to right, Eliborio Resendez Amador; his wife, Barbara Amador; Laura Cruz; and her husband, Abel Cruz. These two couples were lifelong friends. (Courtesy of Hilda Amador Saenz.)

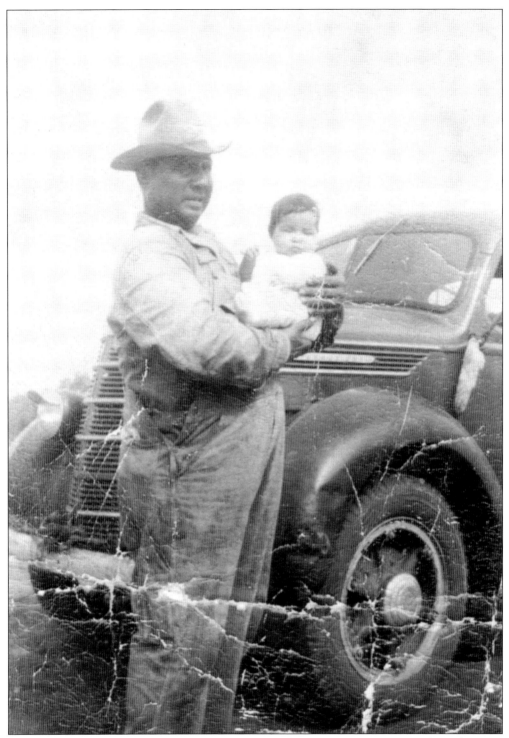
Macario Flores holds his infant daughter Gloria in Jourdanton, Texas, sometime in the early 1940s. Flores worked in the farm labor field in the Jourdanton area. As tradition and necessity met, the entire family was involved in the farm labor business. (Courtesy of Hilda Amador Saenz.)

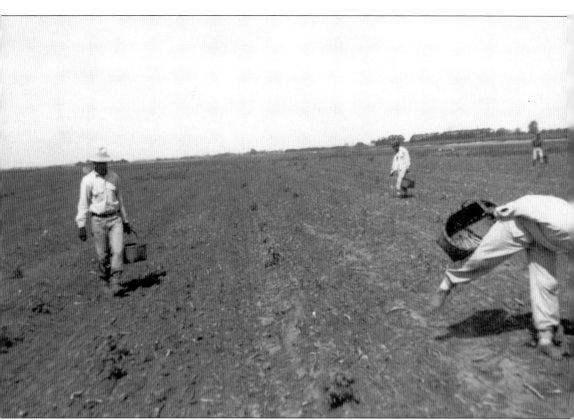

Farm laborers from the Macario Flores family are working outside of Jourdanton. Macario Flores and his family provided labor for the rural agriculture atmosphere of Atascosa County. This type of employment caused the workers to endure long hours in excruciating summers and cold winters. (Courtesy of Hilda Amador Saenz.)

Macario Flores and Lorena (Reyes) Flores pose for a photograph in 1959. Macario spent many years working for Atascosa County as a road builder and maintainer operator. (Courtesy of Hilda Amador Saenz.)

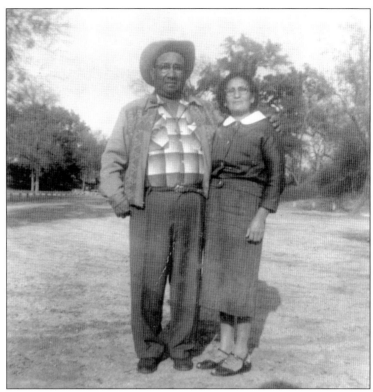

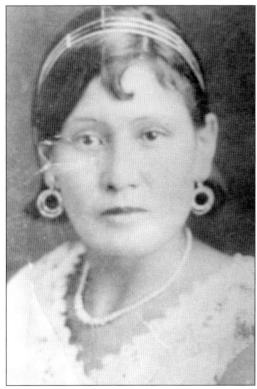

Lorena (Reyes) Flores is pictured in the 1940s. Flores spent many hours making her famous tamales, which are a Christmas tradition in South Texas. The tamalada is a tradition where the family comes together to prepare the tamales annually. (Courtesy of Hilda Amador Saenz.)

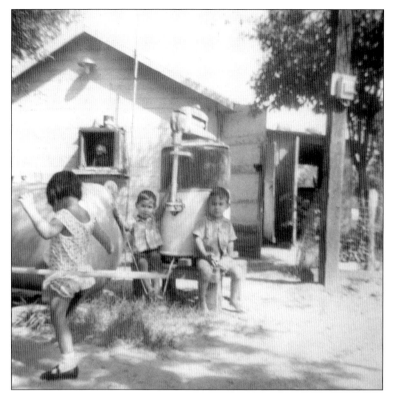

Brothers Alfred and Jose Saenz look on as their sister Angie Ann demonstrates the proper hula hoop method in Jourdanton in 1968. The Saenz family is a mainstay in Jourdanton. Their lineage goes back far as one of Jourdanton's long-standing families. (Courtesy of Hilda Amador Saenz.)

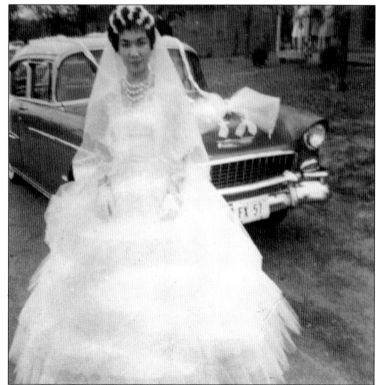

Pictured is the wedding day of Gloria Flores and Willie Cordova Sr. at the H&H Hall in Jourdanton in November 1961. (Courtesy of Hilda Amador Saenz.)

Willie Cordova is pictured during his First Communion at Jourdanton's St. Matthew's Catholic Church in 1951. The statue in the picture still exists at the church. The First Communion is a special event in the spiritual life of Catholic parishioners. (Courtesy of Hilda Amador Saenz.)

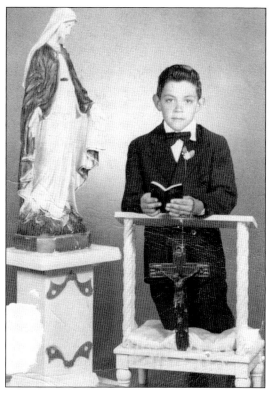

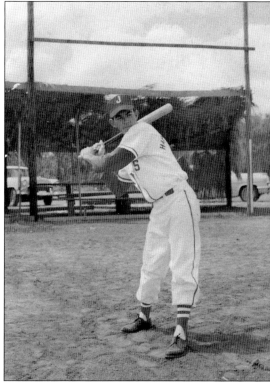

Willie Cordova, a baseball player for Jourdanton High School, was photographed here in the 1960s. Cordova spent his life in Atascosa County and was well known throughout the community. (Courtesy of Hilda Amador Saenz.)

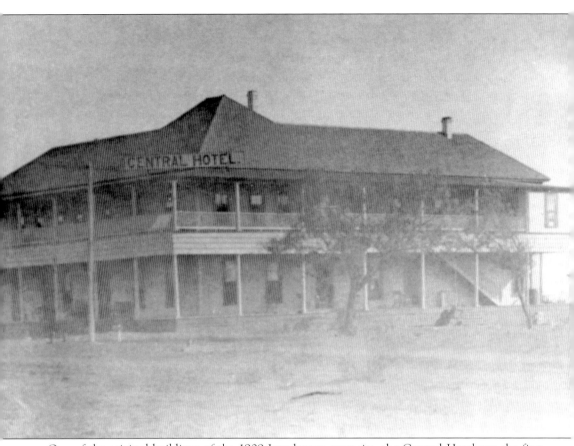

One of the original buildings of the 1909 Jourdanton townsite, the Central Hotel was the first two-story hotel in town. N.E. Willis served as its first proprietor shortly after the city of Jourdanton was platted out. (Courtesy of the Atascosa County Historical Commission.)

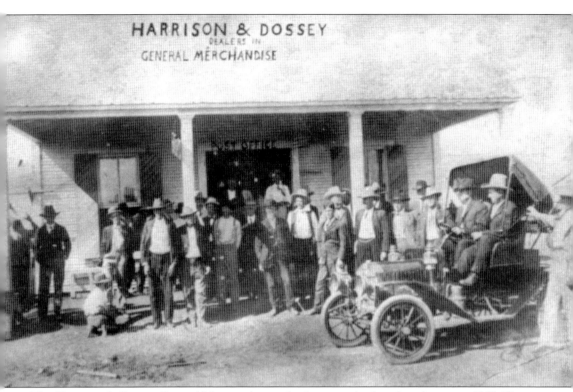

The Harrison & Dossey General Mercantile was the first store built in Jourdanton in 1909. This general store was located at the intersection of Main Street and Simmons Street. The mercantile doubled as the post office for a time while the town was finding its footing. (Courtesy of the Atascosa County Historical Commission.)

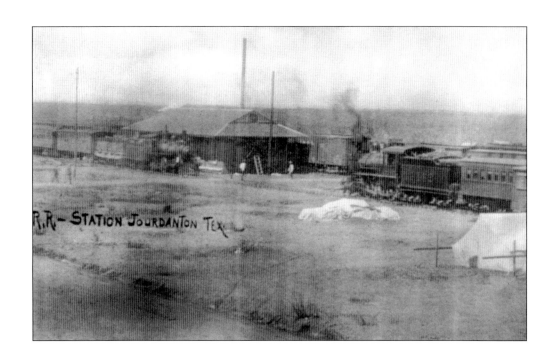

The Artesian Belt Railroad was a rail line that began running through Jourdanton in September 1909. Land speculator Dr. Charles Franklin Simmons was convinced to lay the rail line through Jourdanton by the two businessmen who developed the townsite, Jourdan Campbell and Theodore Zanderson. In 1910, the county seat was moved to Jourdanton, and the city incorporated in 1911. A few years later, the population had doubled due to the addition of the railroad and city growth. (Both, courtesy of the Atascosa County Historical Commission.)

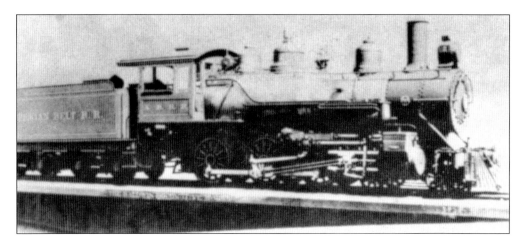

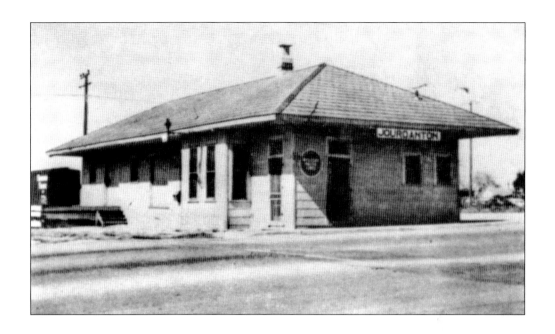

Pictured above is the Artesian Belt Railroad depot in Jourdanton. The city of Jourdanton had two railways traveling through it during a period of time. Peanuts, cotton, strawberries, and onions were just a few of the local produces being shipped through the county and on to distant places that former transportation was unable to get to. The rail lines ceased to travel through Jourdanton in the 1960s. (Both, courtesy of the Atascosa County Historical Commission.)

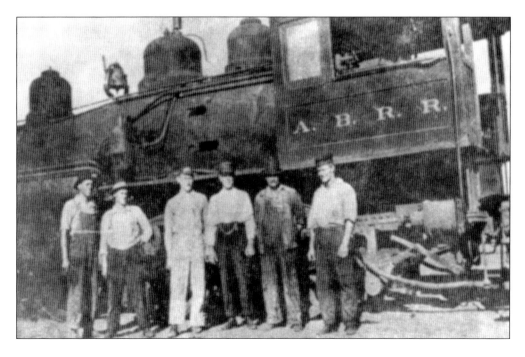

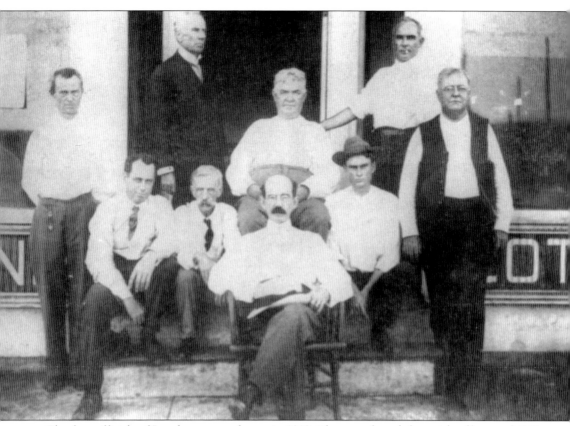
The first officials of Jourdanton are shown in 1910. They are, from left to right, (first row) R.E. Walhoefer, Dr. Marek (seated), George Martin (seated in chair), John McConnell, and J.W. Dixon; (second row) Judge Errington, J.W. Osborne, and W.H. Hill. (Courtesy of the Atascosa County Historical Commission.)

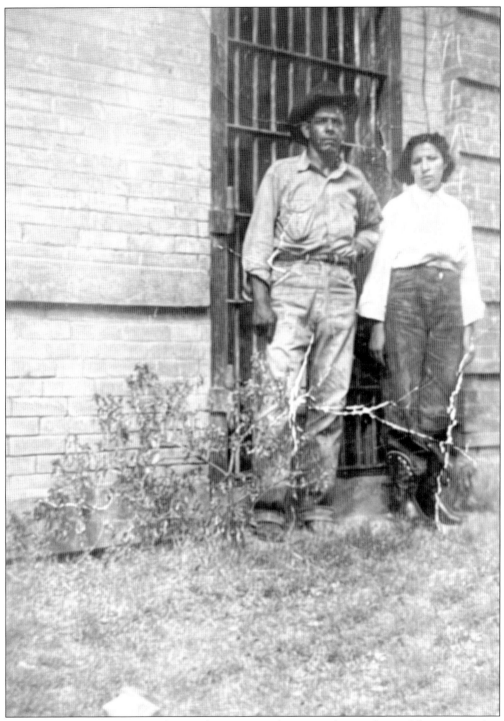

Pete Garcia and his wife, Rosa (Romero) Garcia, are shown standing in front of the county jail in Jourdanton. Pete served as a cowboy and ranch hand for Sheriff McAda, among other dignitaries in the county. Pete also was the foreman of the Dewees Ranch in Wilson County, Texas. Pete Garcia was named Cowboy of the Year in 1977. (Courtesy of Amanda Peña.)

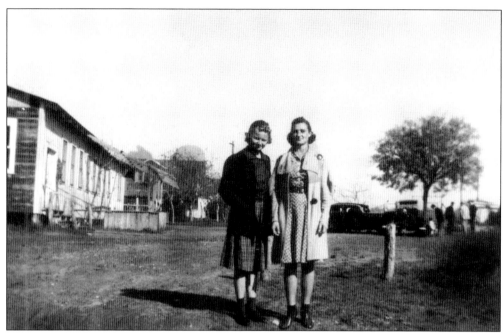

Above, Mary (Bacak) Bartosh and Rita (Netardus) Vyvlecka stand in front of the St. Matthew's Catholic Church Parish Hall. (Courtesy of the Atascosa County Historical Commission.)

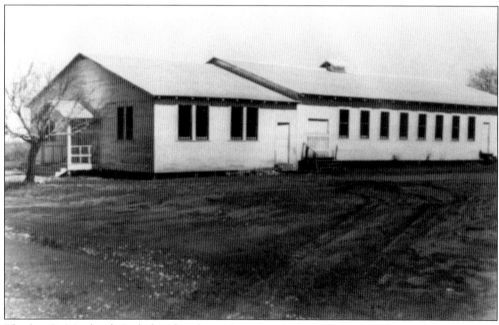

The first St. Matthew's Catholic Church Parish Hall and Church Rectory were built in 1926. In the prior year, Father Smith became the first resident pastor and contributed much to the advancement and evolution of the parish. A second parish hall was built in 1934 under the supervision of Father Benz. (Courtesy of the Atascosa County Historical Commission.)

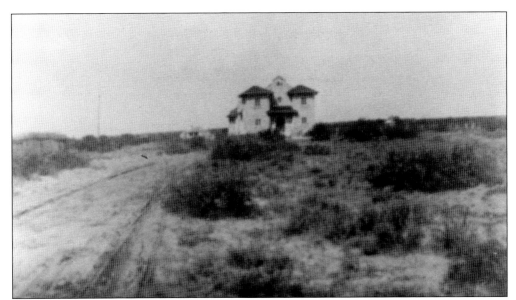

The original St. Matthew's Catholic Church, a mission-style building, was dedicated in 1912. The church was built on land donated by the townsite company for use by Catholic parishioners. A new church was built in 1961 on the same property where it stands today and where the original church was constructed. (Courtesy of the Atascosa County Historical Commission.)

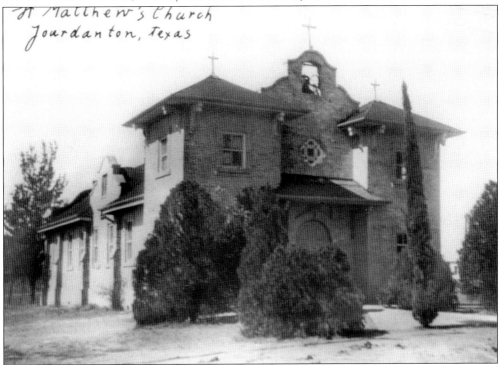

St. Matthew's Catholic Church is pictured in the 1940s. The second church building erected in 1961 utilized the original cast-iron bell from the 1912 church. Today, St. Matthew's Catholic Church continues to serve the Catholic community of Jourdanton. (Courtesy of the Atascosa County Historical Commission.)

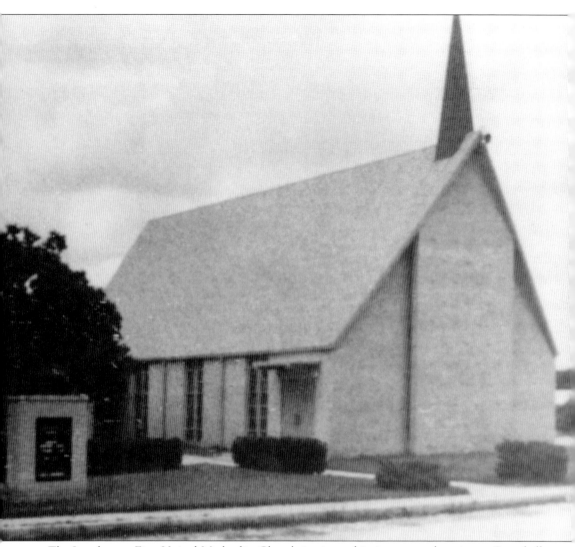

The Jourdanton First United Methodist Church is pictured in its current location at Campbell Avenue and Chestnut Street. The first sanctuary, built in 1941, was moved to this site in 1957 from the original location and later demolished when this current building was approved. (Courtesy of the Atascosa County Historical Commission.)

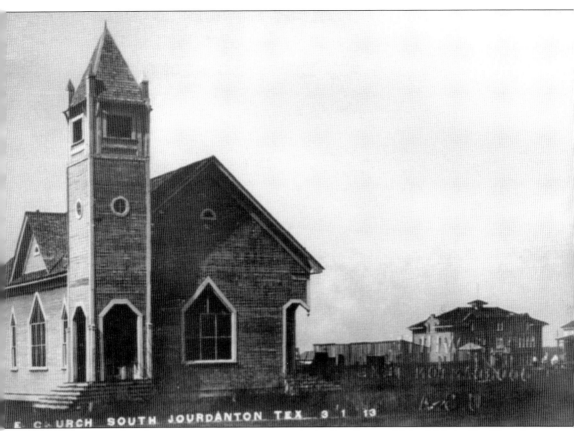

In 1910, a year after the congregation was organized, the Jourdanton United Methodist Church frame building was constructed. The original location was one block east of the current church building. In 1941, this building was razed, and a new structure was erected. The 1941 building was moved to the current church location in 1957. Ultimately in 1964, the current church was constructed and remains a beacon for the Methodist parishioners of Jourdanton. (Courtesy of the Atascosa County Historical Commission.)

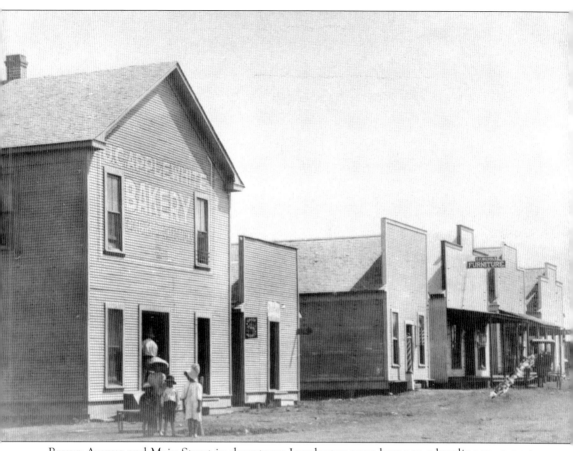

Brown Avenue and Main Street in downtown Jourdanton were home to a bustling town center with several shops for the local citizens. Applewhite Bakery, the Singer Sewing Shop, a barbershop, and Nichols Furniture were a few of the thriving businesses in the early 1910s. (Courtesy of the Atascosa County Historical Commission.)

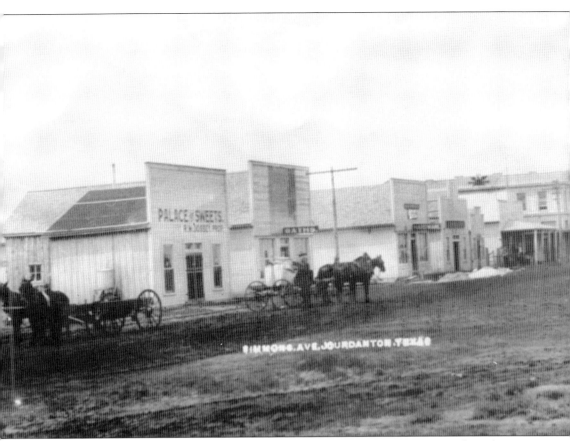

Simmons Avenue and Main Street were also busy sections of the new, infant town of Jourdanton. Palace of Sweets (R. Dossey, proprietor), a business offering baths, and a hardware store are just a few of the businesses seen here. (Courtesy of the Atascosa County Historical Commission.)

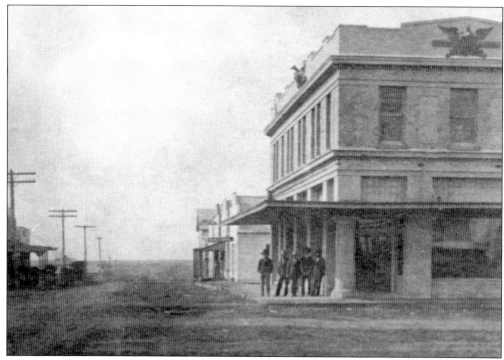

Above, men stand facing east as the photographer faces west on Main Street and Simmons Avenue in Jourdanton. (Courtesy of The Atascosa County Historical Commission.)

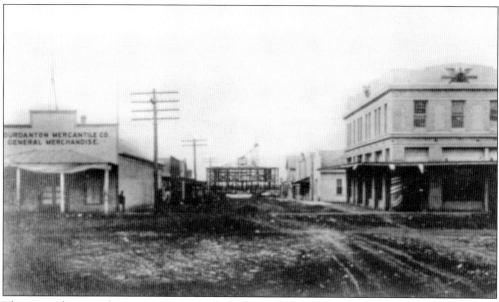

The same photograph vantage point is taken here, and this seems to date itself, as the Atascosa County Courthouse was being built in 1910. Shortly after the inception of the Jourdanton townsite, the county seat was moved from Pleasanton to Jourdanton in an election in 1910. Several local myths exist about the validity of the election even over 100 years after the county seat was relocated. County records, however, debunk all myths and folklore. (Courtesy of the Atascosa County Historical Commission.)

## Four
# McCoy and Campbellton

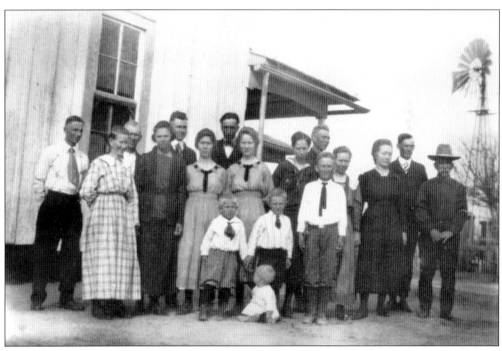

The Thane family and McCoy citizens stand in front of the Thane Store in 1921. The Thane Store provided goods to local citizens from the early 1900s until the 1990s. McCoy is located 14 miles south of Pleasanton, Texas. The railroad and just a few homes remain in the area. (Courtesy of Marilyn Thane Zuhlke.)

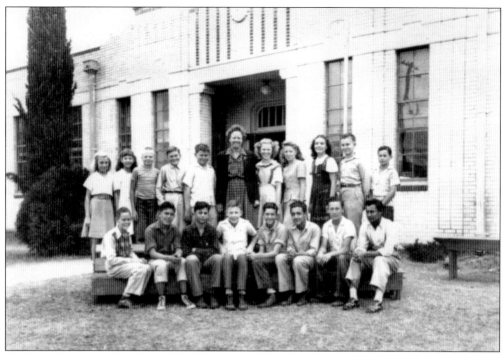

McCoy students stand in front of the Pleasanton School building. Pictured are, from left to right, (first row) Jimmy Parker, Jackie Rivers, Jack Ripps, Richard Poteet, James Traynham, Fred ?, Abram ?, and unidentified; (second row) Freddie Mitchell, Sybil Traynham, Ernest ?, Clifford Shultz, Grover Moiser, a Mrs. Coughran, Marylin Thane, Tommie Jean Moffit, Saura Jane Webster, Teddy Sullinger, and Buddy Schneider. The year of this photograph is unknown; however, the McCoy school system integrated with Pleasanton in 1950. (Courtesy of Marilyn Thane Zuhlke.)

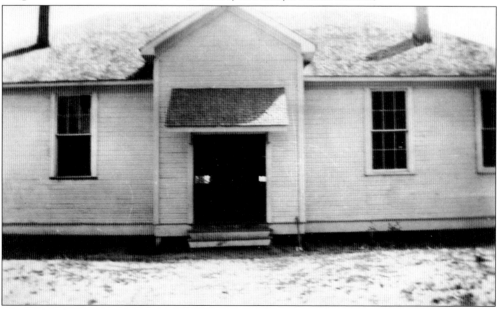

Pictured is the McCoy School building in October 1929. This school building took in all McCoy students from all grades. The building has since been demolished. (Courtesy of Marilyn Thane Zuhlke.)

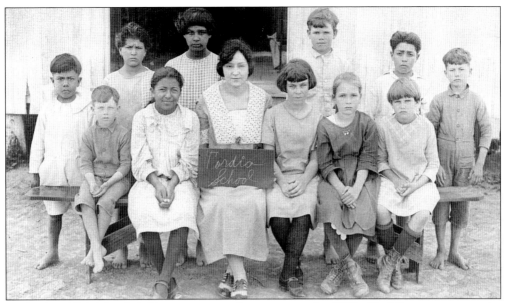

Tordia (Tordilla) School children are pictured sometime in the 1930s. Tordilla was a community that once existed in southeast Atascosa County. This community hosted postal service from 1878 to 1884. The area is known for its Tordilla Mounds, a high elevation point. (Courtesy of Marilyn Thane Zuhlke.)

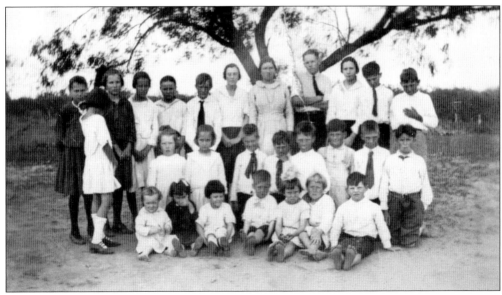

Unidentified children of the Smith School are pictured along with their teacher. Not much is known about the Smith School except that it was for the area surrounding McCoy in southeast Atascosa County. (Courtesy of Marilyn Thane Zuhlke.)

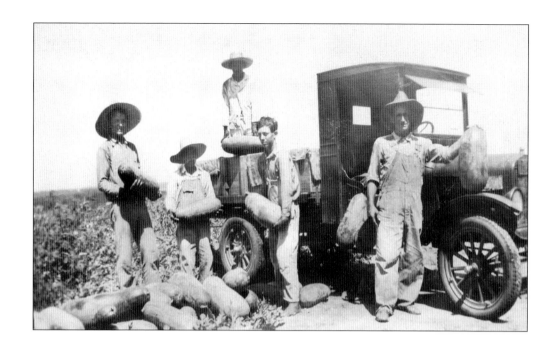

Farming and agriculture have long been a way of life in Atascosa County. Watermelons and cotton were farmed annually, and both became a way to sustain a life and make a living. Today, cotton is still grown, although not as it was decades ago. Watermelons are still grown in abundance every summer. (Both, courtesy of Marilyn Thane Zuhlke.)

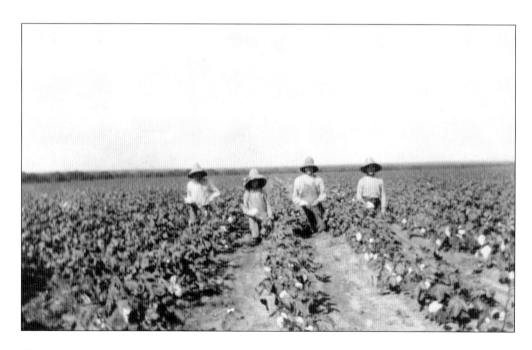

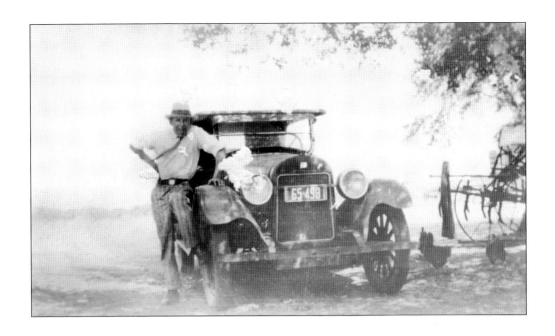

In the 1930s and 1940s, the automobile was rare, and people were still transitioning from the horse-drawn transportation. If someone had an automobile and a camera, they were lucky and were photographed. The young people standing in front of their car below are, from left to right, Norbert Voight, Goswin Voight, and Emily (Voight) Thane. (Both, courtesy of Marilyn Thane Zuhlke.)

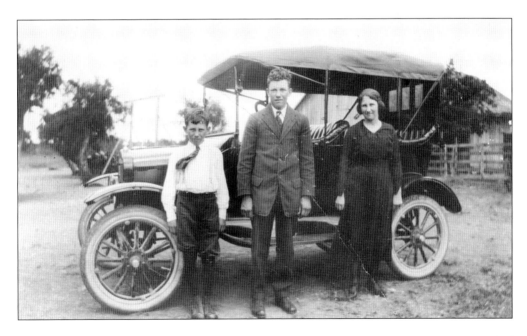

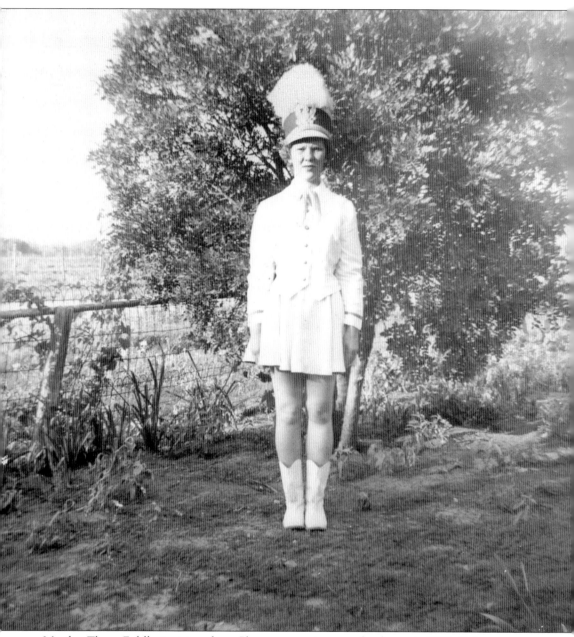

Marilyn Thane Zuhlke is pictured as a Pleasanton majorette at her home in 1949. Majorettes were used as the entertainment and pace of the high school marching band during football games. (Courtesy of Marilyn Thane Zuhlke.)

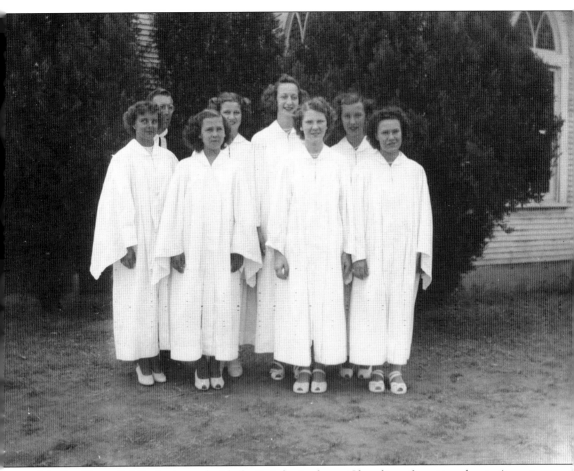

Marilyn Thane Zuhlke is pictured with the St. John Lutheran Church confirmation class in August 1949. In the Lutheran Church, the rite of confirmation is usually performed by adolescents of the congregation. St. John Lutheran Church of Jourdanton, Texas, is a historically recognized church since 2009. (Courtesy of Marilyn Thane Zuhlke.)

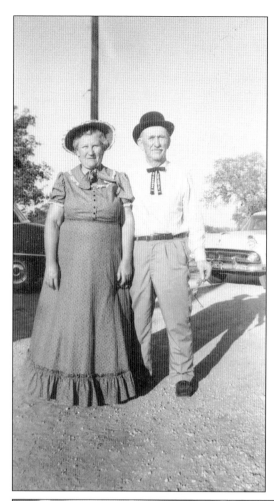

Emily and William Thane were photographed at left and below with unidentified people in October 1956. During this time, Atascosa County held a centennial celebration. Since Atascosa County was established in 1856, the centennial took place in 1956, during the cooler months. The county had celebrations, parades, barbecues, and games throughout various towns of the county. These photographs depict people participating in the "Dress Up like 1856" competition. A beard and mustache contest was also hosted for men to participate in. (Both, courtesy of Marilyn Thane Zuhlke.)

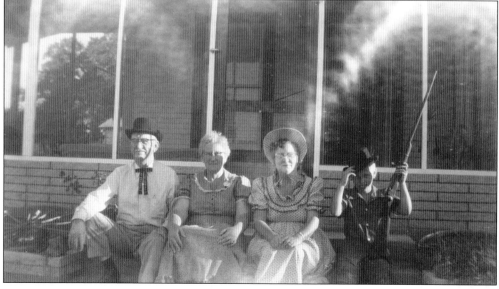

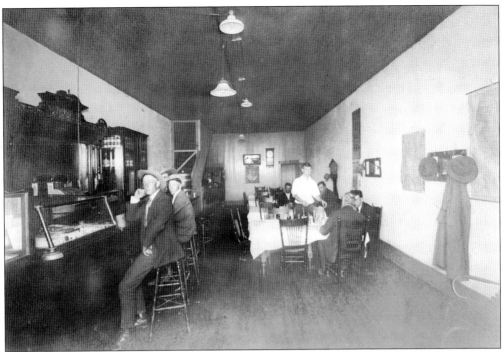

McCoy, Texas, is a rural, unincorporated town that once boasted a schoolhouse with up to 130 students, a railroad station, a general store, a post office, and residence homes. Today, just the railroad tracks, a water company, and a small population exist. These two photographs are an example of life in McCoy. (Both, courtesy of Marilyn Thane Zuhlke.)

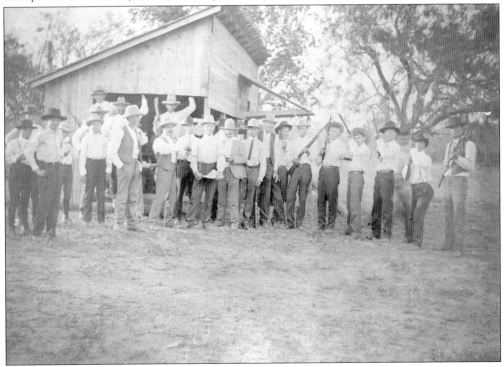

Taken on April 8, 1931, these photographs show the wedding of W.T. Thane and Emily Voigt in McCoy, Atascosa County, Texas. The Thane family settled in McCoy, Texas, and still have relatives living in the area today. McCoy is considered a ghost town with only a railroad and a few residences in the former thriving town. (Both, courtesy of Marilyn Thane Zuhlke.)

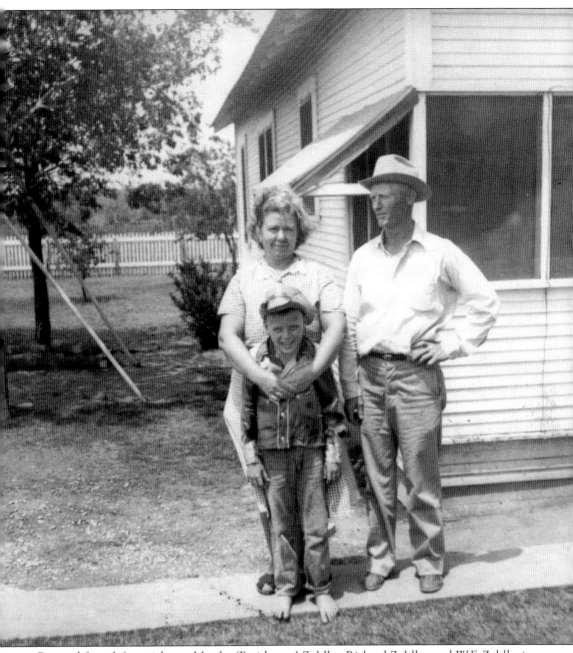

Pictured from left to right are Martha (Breitkreutz) Zuhlke, Richard Zuhlke, and W.F. Zuhlke in Jourdanton in 1951. (Courtesy of Marilyn Thane Zuhlke.)

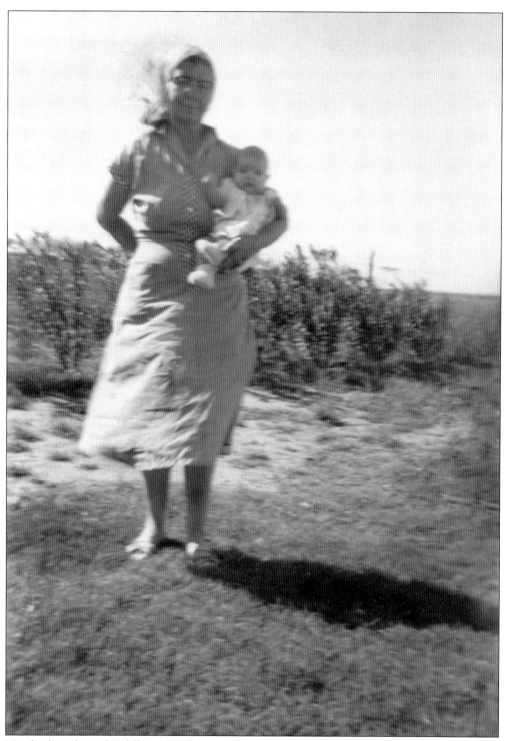

Martha (Breitkreutz) Zuhlke of Jourdanton is holding her second of eight grandchildren, Beverly Zuhlke, now Tymrak. Beverly was three or four months old when this photograph was taken in early 1957. (Courtesy of Marilyn Thane Zuhlke.)

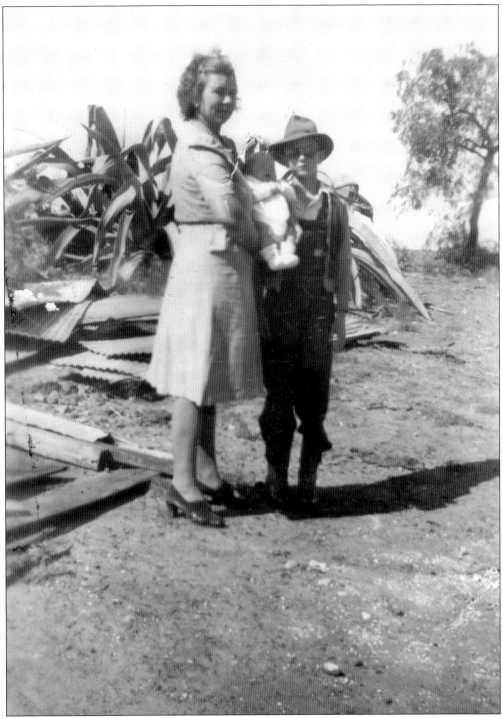

From left to right, Martha (Breitkreutz) Zuhlke, Richard Zuhlke (infant), and Harold Charles Zuhlke are pictured in 1942. The Zuhlkes worked as sharecroppers, living in Jourdanton, Charlotte, and La Parita in Atascosa County. Their family moved and relocated as they sought seasonal work. (Courtesy of Marilyn Thane Zuhlke.)

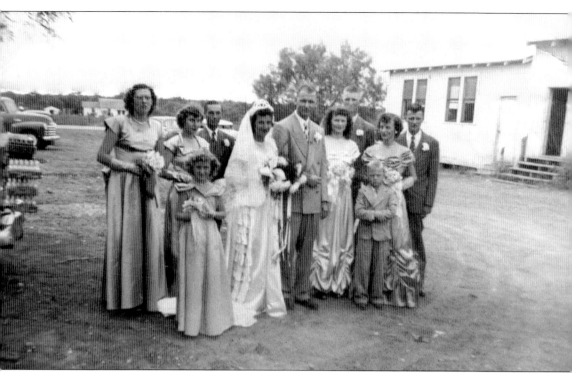

Pictured above is the October 8, 1949, wedding of Georgia "Georgie" Agnes Juricek (age 19) and W.F. "Billy" Zuhlke Jr. (age 22) at Jourdanton's St. Matthew's Catholic Church. Pictured are, from left to right, unidentified, Rosemary Pesek, Joeneatte Tymrak (flower girl), Joe Juricek (Georgie's brother), Georgie, Billy, Ann Pesek, Harold Zuhlke (Billy's brother, age 17), Ethel Breitkreutz (age 20), Richard Zuhlke (ring bearer and Billy's youngest brother, age seven), and Blaise Netardus. (Courtesy of Marilyn Thane Zuhlke.)

Pictured are, from left to right, Georgie and Billy Zuhlke with Ethel (Breitkreutz) Biddle. In the background are Joe Juricek and Harold Zuhlke. Billy was the 1964 Citizen of the Year and the founder of Jourdanton Finance Company after his 1977 retirement from Jourdanton State Bank. (Courtesy of Marilyn Thane Zuhlke.)

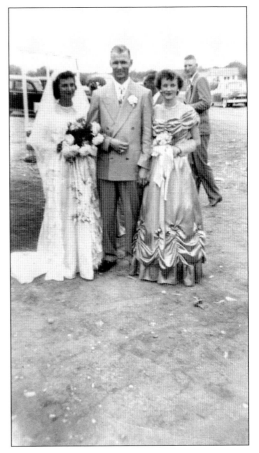

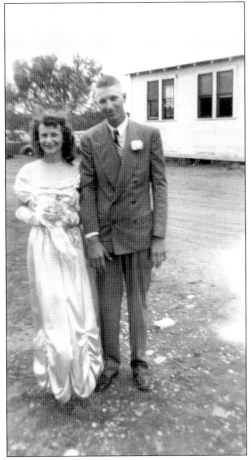

Ann Pesek and Harold Zuhlke are pictured at the wedding of Georgie and Billy Zuhlke in Jourdanton. (Courtesy of Marilyn Thane Zuhlke.)

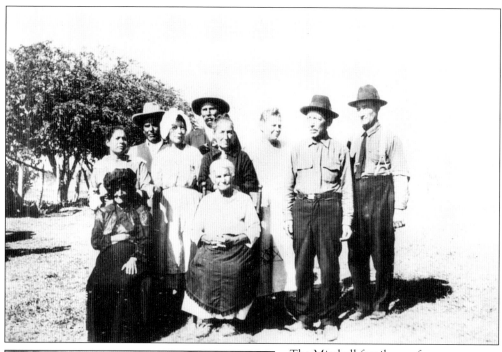

The Mitchell family was from Campbellton, Texas. The Mitchells were pioneers and prominent members of the community. (Courtesy of Irene Gonzales.)

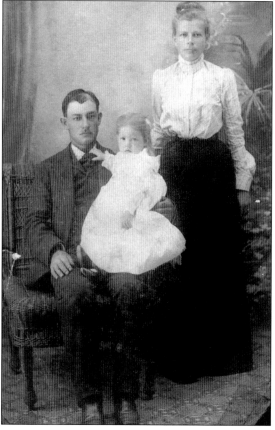

Frank Mitchell, Thelma Mitchell, and Louisa Mitchell are pictured in Campbellton, Texas. (Courtesy of Irene Gonzales.)

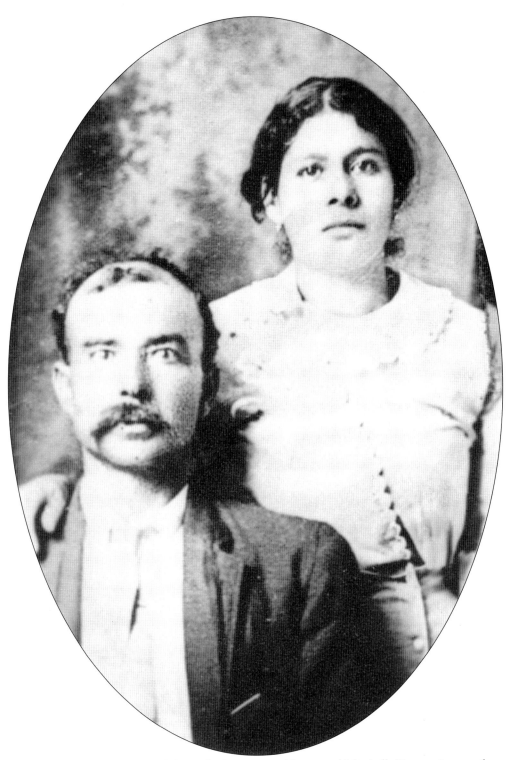

Henry Mitchell is pictured with his wife, Concepcion (Contreras) Mitchell. Concepcion was from Goliad, Texas. (Courtesy of Irene Gonzales.)

# Discover Thousands of Local History Books
## Featuring Millions of Vintage Images

Arcadia Publishing, the leading local history publisher in the United States, is committed to making history accessible and meaningful through publishing books that celebrate and preserve the heritage of America's people and places.

Find more books like this at
**www.arcadiapublishing.com**

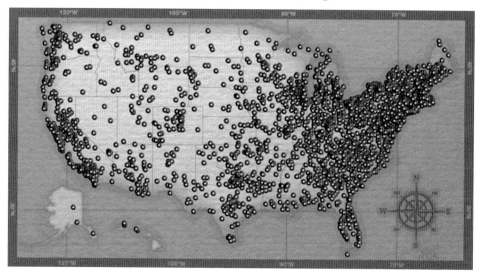

Search for your hometown history, your old stomping grounds, and even your favorite sports team.

Consistent with our mission to preserve history on a local level, this book was printed in South Carolina on American-made paper and manufactured entirely in the United States. Products carrying the accredited Forest Stewardship Council (FSC) label are printed on 100 percent FSC-certified paper.